RICHARD ESTES:
THE URBAN LANDSCAPE

Museum of Fine Arts, Boston
May 31– August 6, 1978

The Toledo Museum of Art
September 10– October 22, 1978

Nelson Gallery-Atkins Museum, Kansas City
November 9– December 31, 1978

Hirshhorn Museum, Washington, D.C.
January 25– April 1, 1979

RICHARD

THE URBAN LANDSCAPE

Essay by John Canaday

Catalogue and Interview by John Arthur

Museum of Fine Arts, Boston

and

New York Graphic Society, Boston

"Richard Estes: The Urban Landscape" is another in a series of exhibitions in which prominent guest curators are invited to present what they regard as the best and most important work being done in contemporary art. Christopher Cook's "Douglas Huebler," Drew Hyde's "Boston Collects Boston," Carl Belz's "Sproat and Rohm," and John Arthur's "Alfred Leslie" are among the choices of this department within the last five years, displaying the diversity of viewpoints and trends in today's art world.

KENWORTH MOFFETT, *Curator, Contemporary Art*

Copyright © 1978
by the Museum of Fine Arts, Boston, Massachusetts

Library of Congress catalogue card no. 78-59702

ISBN 0-87846-126-4

Type set by Wrightson Typographers, Newton, Massachusetts
Color separations and printing by Acme Printing Co., Inc.
Medford, Massachusetts

Designed by Carl Zahn

FOREWORD

I would like to thank the Museum of Fine Arts for allowing me the opportunity to curate this long overdue and obviously significant exhibition. An endeavor this complicated could not have been brought to fruition without the assistance of their excellent staff. Special thanks are extended to Kenworth Moffett and Deborah Emerson, Department of Contemporary Art; Lynn Herrmann, Registrar's Office; Carl Zahn and Judy Spear in Publications; and Tom Wong in the Design Department. Toni Junkin of the Department of American and New England Studies, Boston University, prepared the bibliography, and handled the difficult task of producing an accurate transcript from more than three hours of tape; Allan Stone and Joan Wolff of the Allan Stone Gallery assisted on numerous aspects of the exhibition; Ellery Kurtz of the Andrew Crispo Gallery and Louis Meisel lent helpful support; and Eric Pollitzer photographed most of the paintings in the New York area. We are especially grateful to Richard Estes for his cooperation and patience and to John Canaday for his excellent, spirited essay.

Obviously, this exhibition would have been impossible were it not for the generosity and cooperation of the following collectors and institutions:

Acquavella Contemporary Art
Mr. and Mrs. H. Christopher J. Brumder
Mr. and Mrs. R. A. L. Ellis
Mrs. Marie C. Estes
Graham Gund
Hirshhorn Museum and Sculpture Garden, Smithsonian Institution, Washington, D.C.
Paul Hottlet
Frances and Sydney Lewis
Ludwig Collection, Aachen
Nelson Gallery-Atkins Museum, Kansas City, Missouri
Neumann Family Collection
Mr. and Mrs. Stephen D. Paine
Allan Stone Gallery, New York
H. H. Thyssen-Bornemisza Collection
Toledo Museum of Art, Toledo, Ohio
Whitney Museum of American Art, New York

And in closing, very special thanks to Abby Zonies and José Saenz for their contributions and encouragement.

JOHN ARTHUR
Gallery Director, Boston University

John Marin. *Lower Manhattan (Composition Derived from Top of Woolworth),* 1922. Watercolor and charcoal with paper cutout attached with thread, 21⅝ x 26⅞ in. The Museum of Modern Art, New York; Acquired through the Lillie P. Bliss Bequest.

INTRODUCTION

The triumphant revival of realism in American painting has also revived a schism nearly as old as our century, and reversed the roles of the opposing factions. After all these years, the doctrine of realism has been amended to look forward instead of backward, leaving the abstractionists as the sit-tight sect of modern art and turning the new realists into secessionists. Against this background a debate goes on, I am told, as to whether the art of Richard Estes comes from a painterly realistic tradition or, in spite of his acutely realistic detail, from an abstract one.

There are early Estes paintings going back to 1964 and 1965 to support the realists' contention, but for that matter there are early Mondrians that show the master of rectilinear abstraction as a picturesque landscapist. And there are sections of Estes's later cityscapes where the super-realistic details are as concisely mitered as the rectangular sections of the most ascetic Mondrians. Any moderately well informed student of twentieth-century art can play this game of give-and-take between realism and abstraction to support either doctrine.

It is natural that both sides should want Estes on their team. Everybody loves a winner, and Estes is a winner by whatever standard you use to measure him, from the crass but potent measure of success in the marketplace to the recondite areas of analytical criticism where what an artist actually does is less important than the potential he offers critics for the invention of intramural esoterica. In between these extremes there is Estes's unusually wide range of popular appeal. His meticulous rendering of arresting perspectives satisfies innocents who still think of paintings as pictures that are admirable to the extent that they are executed with technical prowess, while a knowledgeable audience responds to the aesthetic variant that Estes has brought to the American cityscape.

Never before have there been cityscapes exactly like these, where the haphazard conjunctions of commonplace details are transformed into a matrix that would be violated if any of its multitudinous bits and pieces were

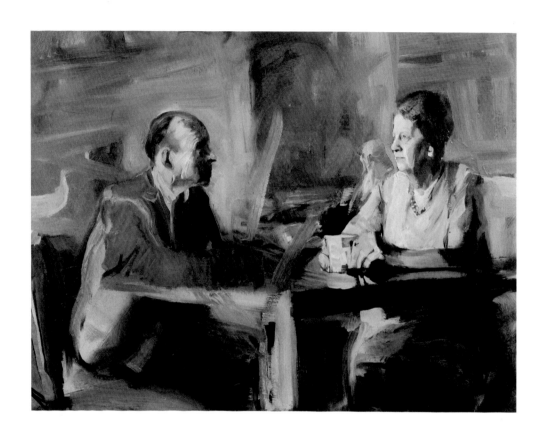

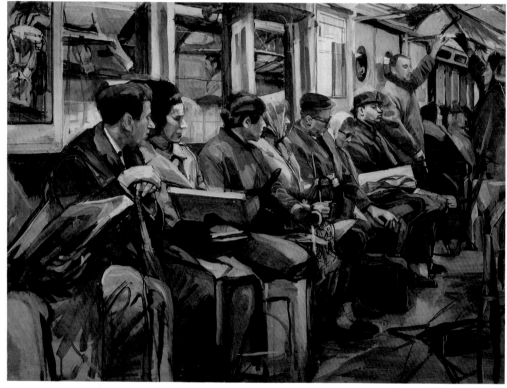

1 *Untitled* (early figure painting), 1965

2 *Subway Passengers* (underpainting), 1966

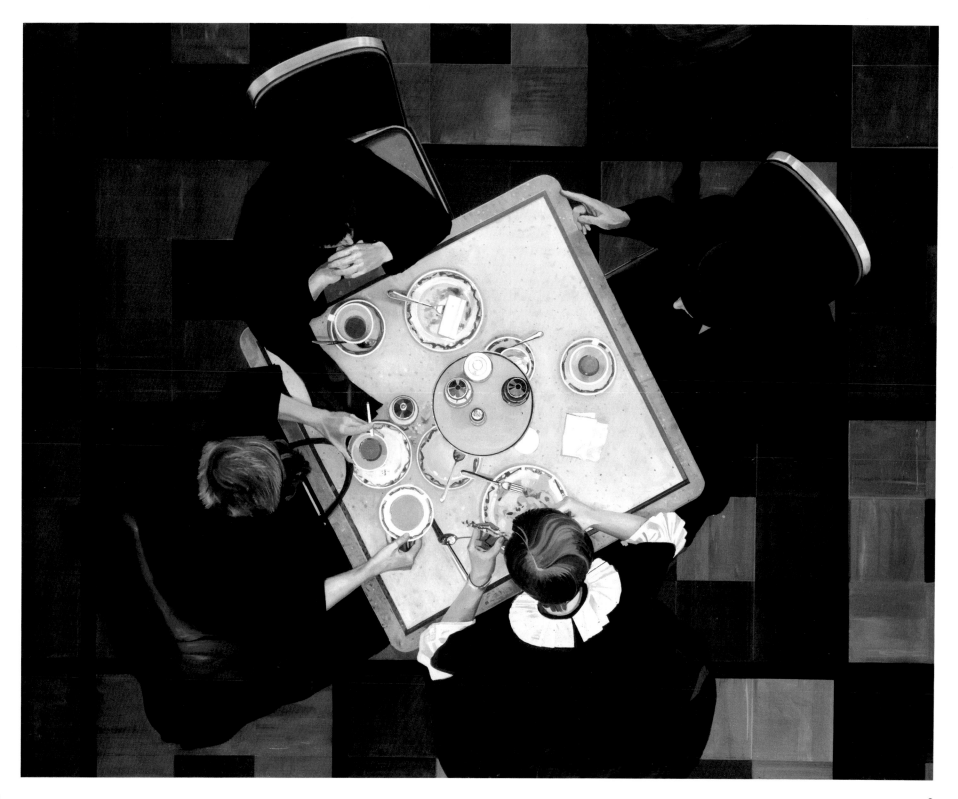

3 *Automat*, 1967

excised from the mass. *The Candy Store* of 1969, although less subtle than later paintings, is a good example of this basic point. If the function of art is to impose order on the chaotic material of human experience (as good a definition of the classical principle as I can summon up), then Estes is a classicist in paintings like this one—but a classicist who, unlike such predecessors as Poussin and Jacques-Louis David, is not free to synthesize his subjects or even to idealize them—unless the extremity of his tidying-up can be called a kind of purification.

At its most elementary level *The Candy Store* is a staggering enumeration of details down to each chocolate and each salted nut in the trays in the window. There are hundreds of plodding talents across the land who in that respect can do as well as Estes, yet produce nothing more interesting than inventories. They seem incapable of mastering even the most obvious device by which Estes clarifies and unifies a subject that in a photograph would be a mess—this device being the manipulation of simple perspective.

All objects in realistic paintings have a double life, existing simultaneously as three-dimensional volumes in space defined by perspective, and as two-dimensional patterns on a flat surface. Estes makes the most of both aspects. The fluorescent tubes of the lighting fixtures on the ceiling of the candy store, for instance, supply a slashing two-dimensional angular pattern on the surface even while respecting the rectilinear purity of the three-dimensional scheme. And everything—glass, metal, paper, chocolates, nuts, and neon—is purified by a preternatural polish. "Preternaturalism" would be at least as good a term as "super-realism" for the school in which Estes is usually classified.

Super-realism eschews suggestion and depends on exact statement, a simple credo that needs to be better understood by painters who do not recognize that "exact statement" involves more than sharp definition. Relative tonalities (that is, degrees of light and dark) and relative color intensities must be more accurately observed and reproduced, or more consistently modified, in super-realism than in any other form of painting if a detailed reproduction of the visual world is to hold together as a work of art. Estes's adjustments of these relationships, always subtle, is most impressively demonstrated in his control of illusionistic reflections like that of the unseen building reflected in the window of the candy store, or the side-by-side Pepsi sign over the door and its adjacent reflection.

In later paintings Estes is increasingly preoccupied with the interplay of reality and reflection, until the intersections and overlappings of walls, floors, and sheets of glass in windows or doors, and the reflections and re-reflections of all of them intermingled, become remindful of the intersecting transparent planes of analytical cubism's "fourth dimension." And there lies a stronger tie to abstraction than the two-dimensional geometric patterns that can relate a well-selected fragment of an Estes to an entire Mondrian.

But the more we dwell on these resemblances, the less important they become. Any artist working in our time, saturated as it is with art exhibitions and literally millions of illustrations of modern painting in magazines, would have to be dim-witted not to absorb, even in spite of himself, the stylistic contribution if not the aesthetic theory of a movement as all-permeating as cubism has been. What it comes down to is that the art of painting today is multidirectional, with all these directions so interbred with one another that such terms as "realist," "abstract," "classical," and "romantic" can be juggled to mean almost anything you want them to. They remain valuable primarily as pigeonholes by which the story of art can be put into chapters.

Estes fits best into the pigeonhole of realism (super-realism subdivision), but the important thing about what he is doing is that his is a truly modern art, as all the best art has always been. His form of realism belongs to our moment because it could not have come about without the adventure of twentieth-century abstract art behind it. Both teams may claim him.

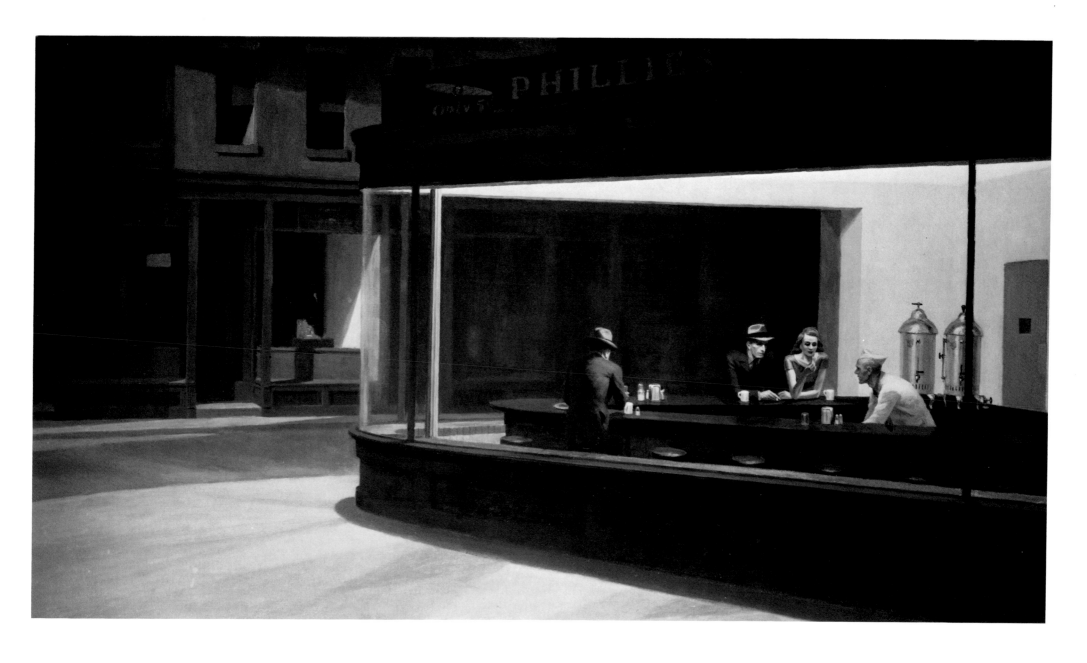

Edward Hopper. *Nighthawks,* 1942. Oil on canvas, 30 x 60 in. The Art Institute of Chicago;
Friends of American Art (1942.51)

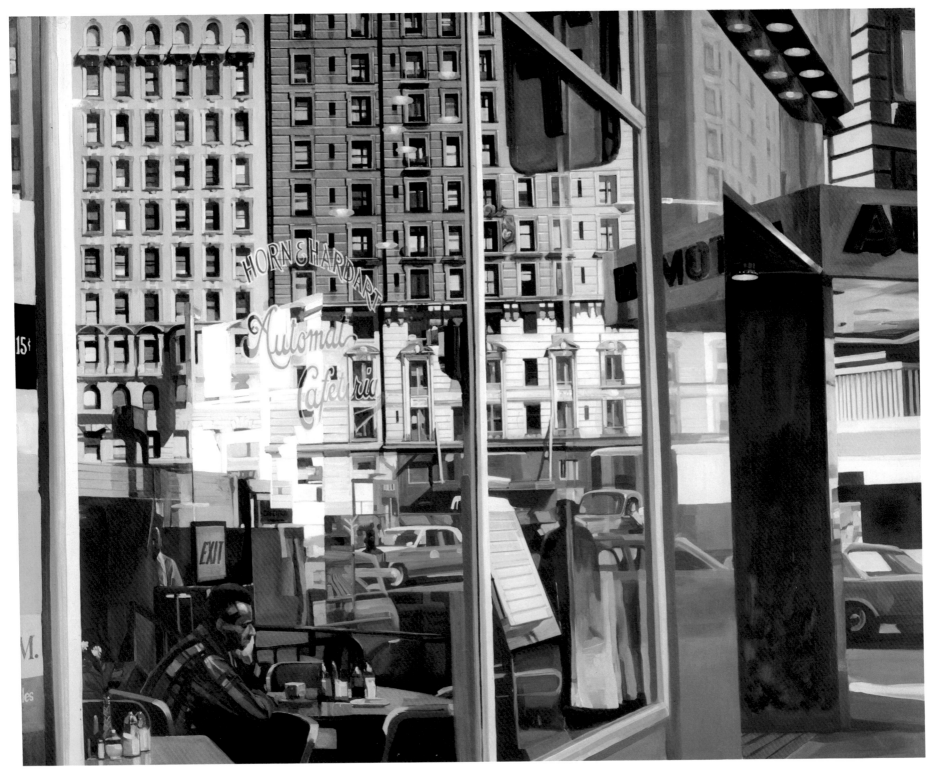

4 *Horn and Hardart Automat*, 1967

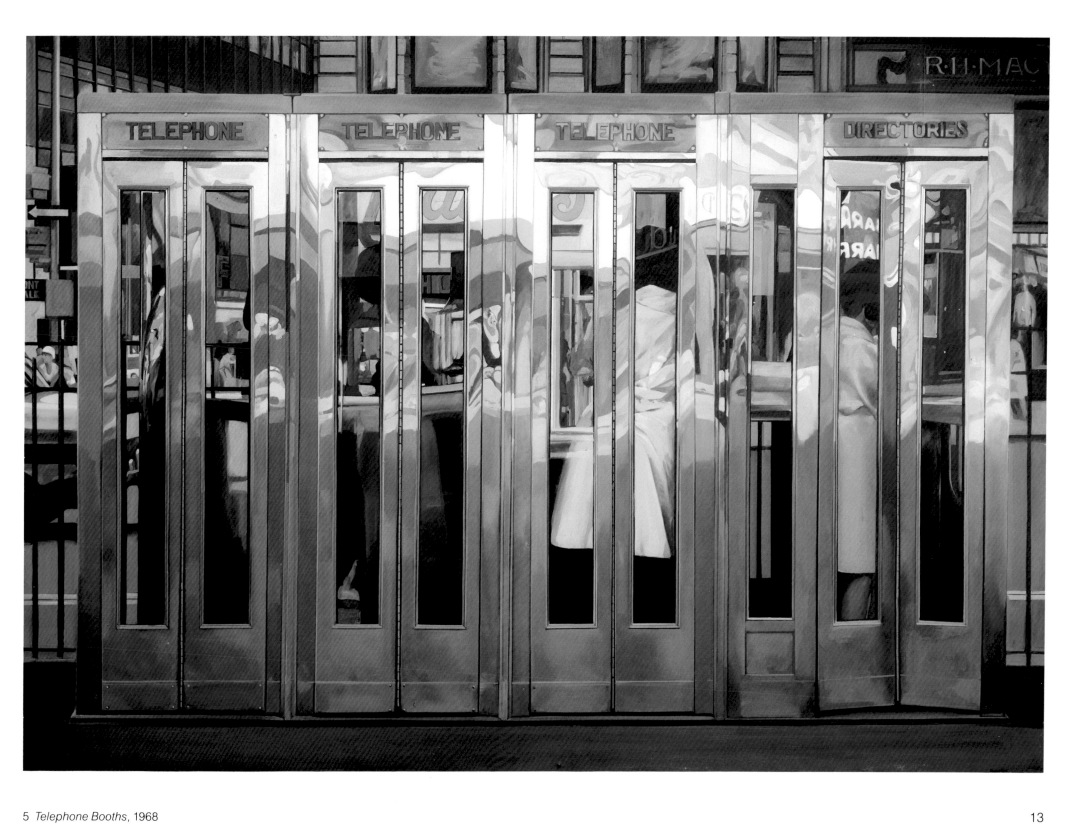

5 *Telephone Booths*, 1968

If everything said so far suggests that Estes's cityscapes are primarily exercises in hybridizing illusionistic realism with post-cubist formal devices, nothing could be more wrong. It is true that his streets and buildings serve him as raw material for formal invention in the way the cubists were served by the mandolins, the fruit bowls, the table tops, and the folded newspapers that they combined and recombined in still life after still life where the interest lay in the doing. But Estes's vocabulary of city motifs serves him in another and more important way: his work is the temporary end result (all end results in art being temporary) of a long tradition of cityscape painting as a revelation of man's reaction to his self-created environment, a sub-theme in medieval and Renaissance art that surfaced in the eighteenth century with Venetian painters' glorification of their city, was continued in the nineteenth with a wider range (picturesque slums were added to the catalogue of interesting urban areas), and in the twentieth became a major theme, with New York City as the most rewarding subject.

New York is our century's generic city just as Paris and London were those of the nineteenth. Painters have tended to divide New York's complicated entity into two contrasting aspects—the city's driving, inexorable force epitomized in John Marin's semiabstract expressionistic interpretations, where the skyscrapers of lower Manhattan explode with energy, and the secluded crannies painted by Edward Hopper, where shelter from the city's dehumanizing assault may be found at the price of loneliness. It must be significant in some way that the concept of New York as a glorious Frankenstein's monster with a life of its own, independent of the people who built it, has been best expressed by abstract devices, while the fate of these people has been told in terms of humanistic realism.

Estes's New York does not fit well into either division, but can be related to both. Reality and reflections of reality become all but indistinguishable from one another, until reality becomes a kind of fantasy in spite of rigidly explicit factual details. Looking into one of Estes's store windows we can hardly tell what is in front of us and what is reflected from behind us. We are at the center of an environment where our own reality becomes questionable. Undeniably we are present; our position is defined by the exactness of the perspective; we are standing at a point where normally our image would occur somewhere in the galaxy of reflections, but we are ignored as if atomized.

We might force a point and call this isolation an extremity of the city-imposed loneliness that preoccupied Hopper. But why force any issue when what we see is so fascinating? In the end, that is the difference between Estes and the painters who only approximate his effects. We are fascinated by his revelation of the world around us. And revelation—whatever form it takes—is what art is all about.

JOHN CANADAY

A CONVERSATION

WITH RICHARD ESTES

In early September 1977, the following conversation (which has been edited) was recorded at Richard Estes's home on the coast of northern Maine.

With the large painting *Downtown* on the easel in Richard's immaculate studio (a large, elegant space that served as a ballroom in the earlier, more glittering summers of this century), photographs and contact sheets, and a number of early unstretched paintings, we discussed his education, background, and method of painting.

Arthur: You studied at the Art Institute of Chicago at the time Jack and Sondra Beal, Irving Petlin, and Robert Barnes were students there. Did you know them?

Estes: Yes. But not very well.

Arthur: What kind of painting did you do as a student? Did you do any abstract paintings, or has your work always been figurative?

Estes: If you've ever been to a figure painting class and have seen what they were doing—that's what I was doing. Fairly academic paintings and charcoal drawings from the model.

Arthur: So the program at the Art Institute was very structured and academic at that time?

Estes: Well, for me it wasn't because I took only drawing and painting. I didn't take any other courses, such as etching, lettering, lithography, and commercial illustration, but all of those things were available.

Arthur: Did you take art history?

Estes: There was a little bit of art history.

Arthur: Were you considered an exceptional student at the Art Institute?

Estes: I don't know. I was always a very traditional painter. My work was considered very good, but it wasn't the kind of work you would want to hang in your house; it was strictly student studies.

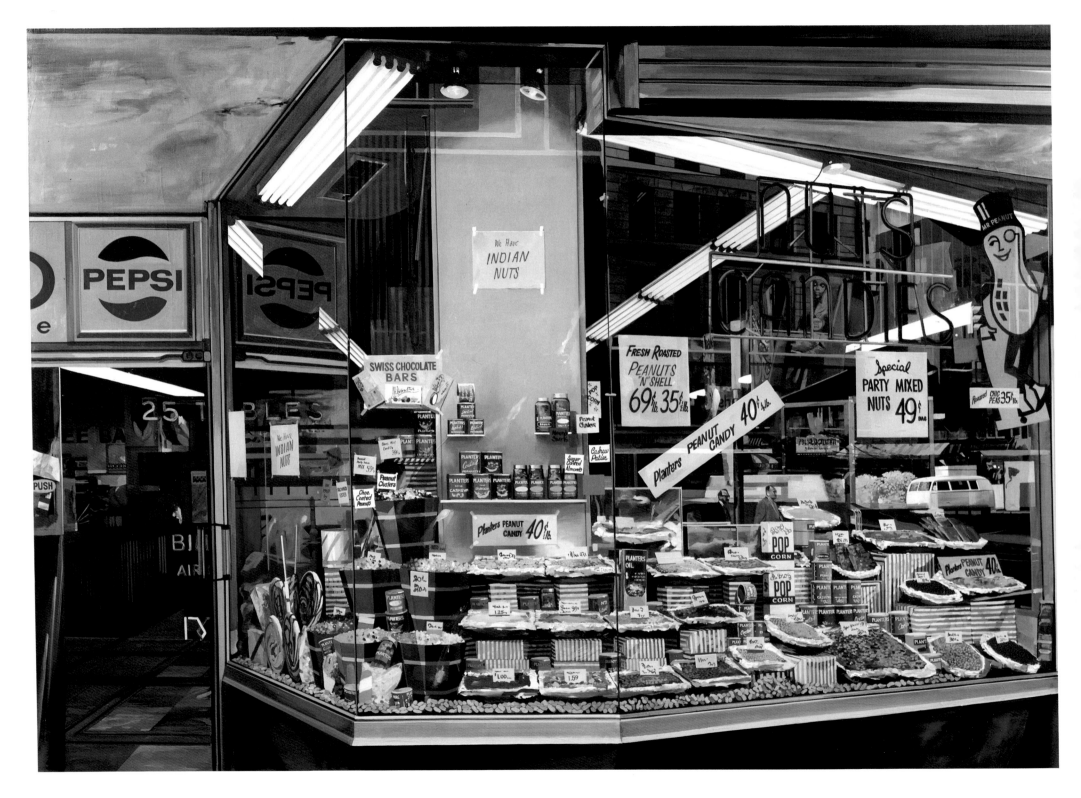

6 *The Candy Store*, 1968-1969

Arthur: But the great thing about the Art Institute of Chicago is that you can walk from the classroom into the museum with its spectacular collection.

Estes: I think one of the best things about being a student there was, for example, trying to do a figure painting and then going up into the galleries to see the way El Greco or Degas did it. You can really put your work in the proper perspective that way—and learn from the paintings. If you see just your own work and the other students', and occasionally that of the teachers, it's not as good.

Arthur: Were there certain paintings in the collection that were important to you at that time?

Estes: A lot of the Impressionist paintings. The big Seurat, *La Grande Jatte,* was very impressive. I don't think what I liked as a student would still be my favorite paintings, though. I liked Renoir a lot then, but I don't like him that much now. Degas I always liked a lot.

Arthur: Weren't most of the teachers and students doing abstract painting at that time?

Estes: No. Most of the students were doing figure painting and charcoal drawings. There were a few students doing abstract painting on the side, but I think there was only one instructor who allowed his students to experiment with abstraction. Most of the instructors insisted that we do fairly academic projects.

Arthur: Which teachers were the most important to you?

Estes: I think I've learned a lot from all of my teachers. My favorite was Mr. P. G. Otis. There was also a drawing instructor, Ms. Isobel Mackinnon, who had studied with Hans Hofmann, so I had a lot of push-pull.

Arthur: So you learned the Hofmann spatial concepts: clamshell space, as opposed to the frontal or planar articulation of space.

Estes: Yes.

Arthur: Jack Beal had the same instructor. The Hofmann attitudes about a clearly articulated space and tension between the objects or figures are always incorporated into his work. Do you feel that you're using those devices now, in these paintings?

Estes: I don't know. With these paintings there are spaces where you go in and you find another space where you come out again. It's just a matter of balance. You probably could find it. What do you think?

Arthur: The one you're working on now *(Downtown)* is certainly a very complicated spatial composition. In other paintings, such as the façades with reflections in the glass, the space is layered and it's difficult to get a fix on the space. The reflection in the glass doubles the space. We see not only inside the picture plane but also what occurs in front of the picture plane or façade. Because of that, they differ from the traditional receding planes. The space in those paintings is fragmented, but much deeper than Cubist space. Of course, Canaletto never had those plate glass windows to play with.

Estes: In reality you don't get that either because the eye tends to focus either on the reflection or on the interior, but both can be painted with equal emphasis.

Arthur: It's like a mirrored dressing room where the space on both sides extends to infinity. You graduated in 1956. What did you do from that period until your first show at Allan Stone in 1968?

Estes: Right after school I came to New York for six months, and then moved back to Chicago. I came back to New York in '59 or '60 and went to work for a magazine publisher.

Arthur: Did you do illustrations?

Estes: Yes. I did some book illustrations on the side but my main job was paste-ups and doing things like color overlays. The illustrator would bring in things and I would clean them up—repair them. After that I went to an ad agency and did more paste-ups, mechanicals, and lettering, mostly very technical jobs.

Arthur: It wasn't the creative side of graphic design.

Estes: No, nothing that took any emotional energy. That way I wouldn't be drained. I really wanted to paint, and would save all my creative energies for when I got home. For a few years I worked during the day and painted at night. By 1965 or 1966, I had managed to get together about $5,000, so I could take a year off. I did a bit of free-lance illustration, which gave me another couple of thousand dollars, and was able to take off for about two years and concentrate mostly on painting. That's when I did the paintings for the first show at Allan's and it explains why the later paintings are more finished. When I was working eight hours a day I was usually pretty tired by evening.

Arthur: At the time you were working for the ad agencies and painting at night, were you going to the galleries? By the mid-sixties Pearlstein was showing regularly at Frumkin, Beal and Katz were showing, Thiebaud had exhibited at Stone, Diebenkorn was at Poindexter, and Morley was making it big with the ocean liners at Kornblee, I believe. The realists had emerged. Did you feel an affinity for them?

Estes: Yes, with some of them. I remember seeing Pearlstein's first show at Frumkin—very brushy paintings, very somber colors, rocks and landscapes.

Arthur: Yes, that's right, landscapes of Italy.

Estes: …and I remember seeing Diebenkorn. I sort of liked them, but I was really only interested in very old-fashioned, traditional painting. I'm still not very interested in Abstract Expressionism or French painters such as Picasso or Matisse. It just doesn't turn me on that much. I like big, solid paintings.

Arthur: Such as Eakins?

Estes: Degas, Eakins, and Hopper.

Arthur: I would assume that you didn't pay that much attention to Pop Art.

Estes: Not really, most of it seemed kind of silly.

Arthur: What about Johns and Rauschenberg, especially their early work?

Estes: I've always admired Johns a bit. He seems to have a nice touch. Rauschenberg just seems sloppy. I don't know what on earth he's trying to do.

Arthur: One of the things that strikes me about your paintings from the early and mid-sixties is that the figures are related in a formal sense—and they are related through the activity they are engaged in, such as waiting for a bus, crossing the street, or riding the subway—but they are usually emotionally isolated, detached from each other. Were you conscious of this?

Estes: Yes. But that's the way they are; when people are crossing the street there's no emotional connection. That's all they're doing—that's simply what I saw.

Arthur: Were those paintings done from photographs?

Estes: Yes, there was just no other way to do them, unless I had hired a model and set the scene up in the studio. It would have been impossible to paint them on the spot. Actually, a lot of the small watercolors were done on the spot.

Arthur: The groups of figures in the automat?

Estes: Yes. I used to sit in the automat and draw, then take the pencil drawings home and add the watercolor.

Arthur: Do you feel that your education equipped you for the kind of painting you do now? Are there things that you wish you had learned in school that you didn't learn?

Estes: Well, school was a beginning. I really learned to paint the way I now paint on my own after I got out of school. When I was in advertising I spent a lot of time doing layouts and quick sketches with magic markers or chalk. I learned a lot about drawing and developed the ability to do things very quickly. That's when I began using photographs. We had a polaroid camera and if we needed a figure, or hands wrapping a package or pointing at something, someone in the office would pose. I would use the photographs to make a quick sketch. Before that I did sketches and preliminary drawings for paintings by the traditional method I learned in school, which I thought was the way a painting had to be made. It seemed rather silly after I saw how much better I could work from photographs. I think that one of the problems with universities and art schools is that it's a rarefied atmosphere. They are out of touch with reality.

Arthur: Reality in terms of the art world?

Estes: In terms of the art world and the way people live.

Arthur: Yes, unfortunately, in most art schools and universities the students are trained to deal with academic issues: drawing, painting, at least a smattering of art history, but in most cases they leave school knowing little or nothing about the business end of the arts: how galleries operate, how one goes about getting a dealer, or what to expect from a dealer. They are not well equipped to make a wise decision about sustaining themselves until they can support themselves from their painting or sculpture. These are very pressing issues that are continually ignored in most of the art schools.

Estes: I never concerned myself with those problems when I was in school, but I think when you get out of school you'll solve the problem or starve—or go on to something else. It's a rat race. But it's a mistake for students to feel that if they go to school for four years they're going to come out as qualified painters.

Arthur: As a student you painted the figure and, I assume, still life and possibly landscapes, but the paintings you now do—with a few exceptions, such as the painting of Venice that you're working on— contain very few natural elements; they are primarily paintings of the man-made environment and objects: metal and glass, automobiles, etc.

Estes: I think the explanation is that for the past twenty years I've lived in a man-made environment and I've simply painted where I've been. If I had lived in Maine, I certainly would not have painted the same things. I would be out there painting rocks and trees. You look around and paint what you see. That's what most painters have done.

Arthur: But you've obviously made choices and decisions.

Estes: Well, one can't do everything.

Arthur: For instance, we see still-life objects every day.

Estes: How often have you seen, in reality, a Chardin still life—I mean a fish lying on a silver plate, a candle, and some apples.

Arthur: But that is a set-up still life.

Estes: Isn't it ridiculous to set up something when the whole world is full of still life?

Arthur: Do you regard the objects in the windows of your paintings as contemporary still life?

Estes: It's still, it's dead. What do the French call it?

Arthur: Nature morte.

Estes: Nature morte.

Arthur: The weather, the season, and the time of day never seem to vary much in your paintings. Is that dictated by the conditions you need for the photographs, or is it a matter of the quality and property of the light that attracts you?

Estes: Well no, you can take photographs with any kind of light. For instance, you can take better photographs with a softer, hazy light because everything is more evenly illuminated. There's more detail in the highlights and shadows.

Arthur: You have never considered a night painting, for instance?

Estes: I've thought about it and rejected it so far.

Arthur: Practically all of the realists, Pearlstein, Leslie, Thiebaud, Beal, are also recognized for their drawings. Some are studies for paintings, but they have produced a lot of finished drawings. With the exception of that small group of drawings done in the automat, which are more than ten years old, you have done very few drawings. Aren't you interested in drawing as an end result?

Estes: I love drawing, but as far as I'm concerned the whole painting is a drawing; you're talking about unfinished drawings, actually, because it's all drawing. To me, painting and drawing are the same thing.

Arthur: Except that you're drawing with color?

Estes: A painting is a drawing with color; a painting is just a more finished drawing.

Arthur: Is that why I've never seen a black and white Richard Estes?

Estes: There are a lot of black and white paintings.

Arthur: By you?

Estes: No, but it's not impossible.

Arthur: But it doesn't interest you?

Estes: No. I wouldn't consider it a finished painting if it were only black and white.

Arthur: Do you feel much empathy or affinity with the contemporary realists?

Estes: Yes. I do feel an affinity with all realist painters; I don't really consider someone a painter unless the individual is a realist. I love realist painting no matter what it is, but it's certainly got to be a painting of something.

Arthur: One fairly consistent attitude among the realists is their reaction against the notion of elitism and the formalist aesthetics.

Estes: Most people aren't interested in art; they're interested in the prestige that art provides, the feeling that they're in on something. I don't think it takes any special mentality to respond to art. It's a natural thing, like enjoying good food. Art is not something that requires indoctrination.

Arthur: How much has it changed your situation, now that there's a waiting list and your paintings sell almost as soon as they go to the gallery? You obviously enjoy a position where there's no financial threat, and you can work the way you want.

Estes: It just gives me more time to paint. I don't have to worry about other things. One certainly works much better not being pestered about paying the rent and selling the work. Those problems don't contribute to getting things done.

Arthur: Obviously, the market never entered into your choice of subject matter.

Estes: No. If I had been thinking of the market I would never have chosen to paint what I'm painting. It was something I had never seen in the marketplace so I had no idea if it would sell or not. I was very surprised when I started selling paintings. I couldn't believe it. I still can't believe it.

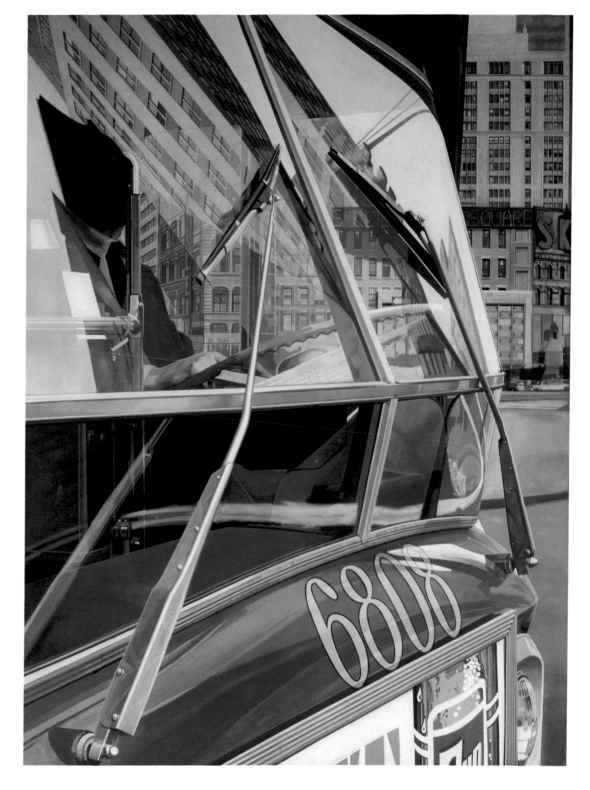

Arthur: Have you felt pressured to stay within the rather limited parameters of your subject matter and painting method?

Estes: What's wrong with doing the same thing over and over again? I think the most—the silliest thing is to try to come up with some new gimmick each year. It's better to really develop and expand on one idea.

Arthur: I think it comes back to what we discussed earlier. In the end the results hinge on the strengths or weaknesses of the individual painter. Some painters who deal with the same subjects repeatedly are pot-boilers, but there is always Morandi rearranging his bottles, or Vermeer, Bonnard, and Vuillard painting the inhabitants within the intimate confines of their own homes. God knows, there's an abundance of hack portrait painters, but that shouldn't make the possibilities for portraiture suspect.

Estes: It's not what it is that makes it good or bad, but how do you define the difference? You can't really verbally express the difference between an Eakins portrait and some very ordinary, mediocre portrait hanging in a bank president's office. It's all a matter of quality.

Arthur: As a student did you do portraits?

Estes: Oh, sure.

Arthur: Did it interest you?

Estes: At the time it did. One of the problems in doing portraits was that it was so inconvenient to find people to pose. It's a matter of working habits. I worked late at night, and whenever I could. With models, set-ups, visits to the scene and all, that just became impossible to manage. Maybe that's another reason I started using photographs. Except through sheer memory there was no other way I could do it.

Arthur: Your first exhibition at Allan Stone was in 1968, so you've been showing now for about ten years. Almost from the first show—and certainly since the "Aspects of a New Realism" in 1969—you have been regarded as one of the major realists, yet, with the exception of a few reviews, there hasn't been, to my knowledge, an article written on your work. You've been included in various articles and books, but there's no book, no catalogue or source of documentation—perhaps three or four color postcards—and yet you have an international reputation. Your paintings are in major collections and museums both here and abroad.

Estes: That seems to indicate that as far as having any real pull, power, or influence, the reviewers, art magazines, and newspapers don't really have much effect. If they did, I wouldn't be where I am. I feel rather relieved that they aren't saying all those things about me. I think the less that has to be said about a work of art the better. If you have to indoctrinate someone into responding, the work is somewhat of a failure.

Arthur: I remember one review in particular; it was really a brutal, vicious attack on your work, apparently triggered by that critic's concern over the prices on your painting (which was incorrect)—and by the fact that she was taught in college that she needn't worry about realism. Was that upsetting at the time?

Estes: Not particularly. The show had just opened and I was getting ready to go to Europe. I don't think I ever read the whole thing; I just glanced at it. It was more upsetting that they trimmed the picture *(Bus Reflection)* on both ends. The painting was carefully balanced with the bus on one side and the reflection on the other; the cropping destroyed the composition. That was the most upsetting part of the review. It was probably better to get a nasty review from her. Knowing what she likes, I would not want to be in that company.

Arthur: Well, that review obviously had no effect on your career.

Estes: No, it was too hysterical. She sounded as though she felt threatened, but I don't know why.

Arthur: Quite a few of the critics and historians object to contemporary realism and argue that it's no longer a viable premise for painting. But most of them have a great deal of admiration for your work. There's something about your paintings that they hold in high regard.

Estes: Yeah. Tell me about it.

Arthur: Do you think of your images as emotionally cool and detached?

Estes: No. Not particularly. I just feel that this is the way I want the paintings to look. Whether they are described as cool or emotionally charged…

Arthur: Or mysterious…

Estes: …or mysterious. I don't think about those things because they're just words. Language is a very limited and flimsy thing.

Arthur: In the early paintings the people are engaged in typical urban activities: waiting for the bus, crossing the street, sitting in the automat, or lounging on park benches—real genre paintings. But in regard to the way they are constructed, these paintings are closer to West Coast painting, particularly Diebenkorn, Bischoff, and Parks. The figures and the environment are generalized; it's never a specific street corner or person. I'm reminded of the backgrounds in Giotto's "Arena" frescoes; the landscape or architecture is more like the backdrop for a play, a stage set, showing us a landscape but not concerned with more specific information. The emphasis on figures in your work begins in the early '60s, and by '63 or '64 the people are much more specific. There is particular information about their dress and features, but the environment is generalized.

The surroundings become much more distinct and specific by the mid-sixties. But rather than moving through the urban landscape, the people are enclosed in very specific architectural elements: phone booths, restaurants, or a city bus. I suppose these are the first works one would think of as Richard Estes paintings. At this point, the urban architecture is dominant. How did that transition occur? Did you simply get more and more interested in the architectural surroundings?

Estes: I think so. What was happening in the background just seemed more fascinating than the figures. I had done what I could with the figures; maybe I was just getting tired of doing them and wanted to do something else—something new.

Arthur: Your use of color also changed simultaneously: from the earth colors and muted grays in the figure paintings to the use of local color. The color has become an important factor.

Estes: I think in a way that was what I had been working toward. The figure paintings are more like big drawings. I was really just fishing around. I didn't know what I wanted to do and the paintings probably reflect my indecision at that time.

Arthur: At that point everything seems to have come together.

Estes: I suppose it was a matter of just trying everything. I took a lot of photographs of people on the street—just wandered around New York photographing people—and I began to notice a lot of other things happening. You know how it is with a 35mm camera and 36 exposures; I was just snapping pictures. If anyone had shown me in 1965 what I would be painting in 1967 I wouldn't have believed it. I was just walking around the city photographing things, and that was what was there. It wasn't that I thought about it or planned it.

23

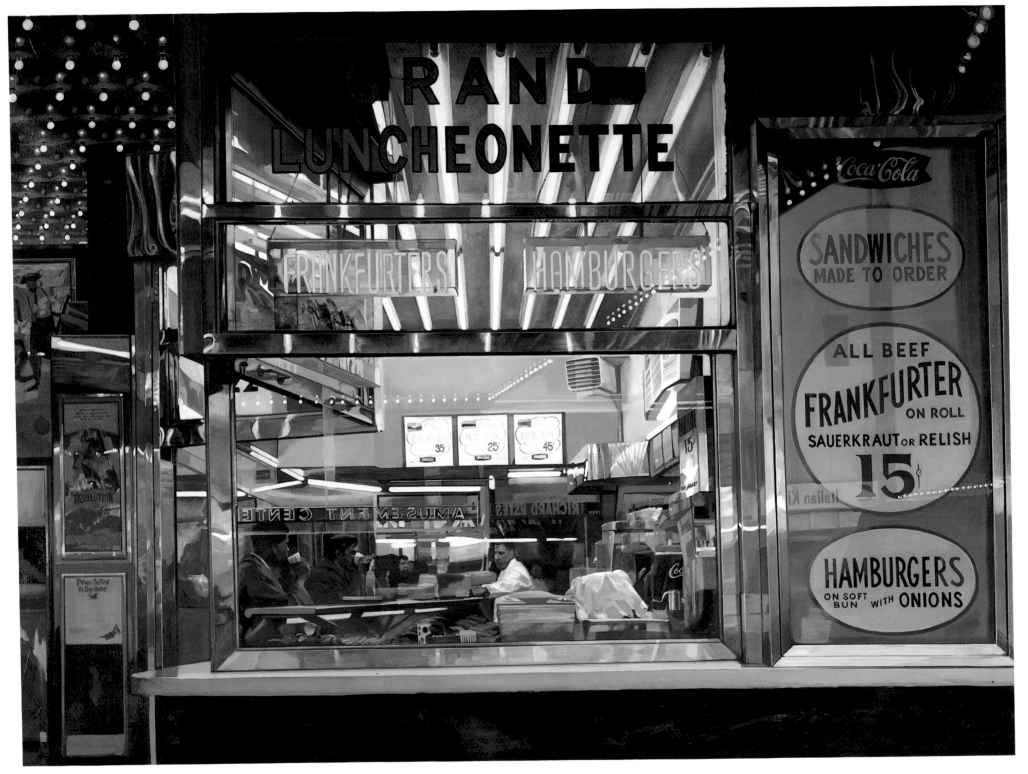

8 *Grand Luncheonette*, 1969

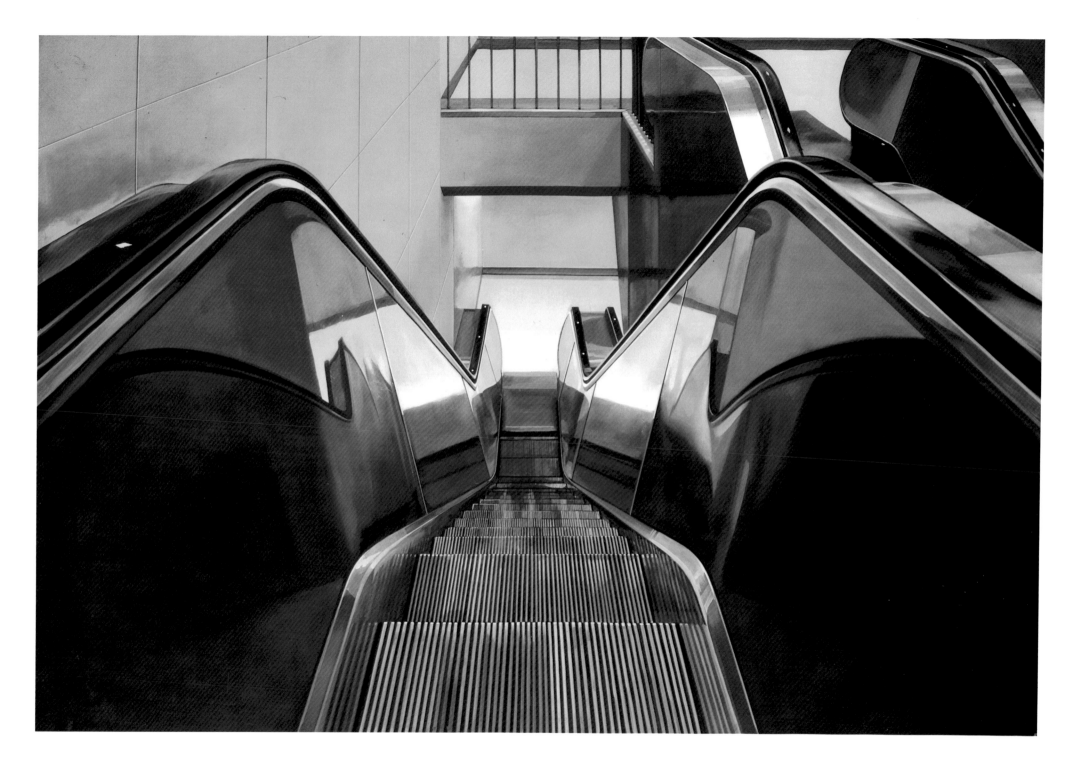

9 *Escalator*, 1970

Arthur: We've got a long tradition of urban images: Guardi, Canaletto, Piranesi, Utrillo, and more recently Marin, John Taylor Arms, Hopper, and Sheeler. The look and materials have changed, though. When you started painting those reflections in the glass and chrome—did you realize that it was quite new and different?

Estes: Yes, except I saw some small Turner watercolors in London a long time ago with distorted reflections in windows—or mirrors perhaps. There's the Van Eyck painting of the Arnolfini Wedding, and the Velasquez "Venus" with the reflection in a mirror.

Arthur: What about photographers such as Atget and Walker Evans? Were you familiar with their work?

Estes: Yes. But I don't think I chose reflections as such; I just found them rather rich and exciting—and stimulating to do. It seemed to open up a lot of possibilities for painting.

Arthur: Were you making the rounds of the galleries trying to get a dealer at that time?

Estes: I had a rather confusing collection of figure paintings and a couple of the reflections. Probably the best one is the *Bus Window*. I showed some of those to the dealers but I hadn't done that much.

Arthur: Were the dealers very interested in what you were doing?

Estes: No, not at all. The only dealers who thought the work had much potential were Ivan Karp and Allan Stone. Ivan was at Castelli and Castelli was handling Pop Art, so Allan was really the only one. He told me he would give me a show in a year, but he didn't see any of the paintings until about a month before the show.

Arthur: I saw the paintings from 1967–1968 only in black and white reproductions, such as the announcement for the show at Allan Stone. Reduced in reproduction, they looked photographic, but in fact these paintings are rather loose and broad, loaded with quite painterly passages, and can be described as signature paintings in the best sense of the term. They are obviously much more quickly painted than the more recent work. What was your production like at that time?

Estes: I could do a painting in a week or two.

Arthur: Are you talking about the large paintings?

Estes: Yes.

Arthur: And they were painted in oil?

Estes: Yes.

Arthur: One aspect that fascinates me: by 1967–68 the figures are reduced to a minor role—usually closed off from the viewer and compartmentalized in the architecture—and by 1970 the figures have completely disappeared from the paintings. There are always traces and clues, such as buses and cars moving down the street, doors opening, but it has become a man-made environment with invisible inhabitants.

Estes: Well, the *Escalator* is a good example. If there is a figure on the escalator it becomes romanticized—a period piece like an Edward Hopper. It changes one's reaction to the painting and destroys the feeling of it to put a figure in because when you add figures then people start relating to the figures and it's an emotional relationship. The painting becomes too literal, whereas without the figure it's more purely a visual experience.

Arthur: Then you want to avoid any storytelling or narrative quality in your paintings?

Estes: Right. Even with the figure paintings I tried to avoid it. I don't want any kind of emotion to intrude. When I look at Eakins—the painting, the color, and the forms—everything is so beautiful that I'm not really concerned about who the people are or what they're doing. The portrait of his wife at the Metropolitan: he could have spent months adjusting the values of that hand. It has nothing to do with

hands, or the woman, or anything emotional. It's just beautiful painting, and it's about painting.

Arthur: In some of the more recent paintings, the *Ansonia,* for example, there's a woman on the sidewalk in the middle ground. Certainly, this figure isn't dominant, but it does help with scale and space. She's rendered like a double exposure. Right?

Estes: I did a number of fuzzy people. That's another way, maybe, of making the figures less involved, so that they don't dominate the picture.

Arthur: There's a lot of confusion about the way your paintings are made. For instance, you are not projecting slides or gridding off photographs. The means and the results are quite a bit different from the hard-core "photo-realists." The images are completely redrawn and things get moved around even if it is slight and subtle. In the end, the painting is not an imitation of the photograph.

Estes: Even with a 4 x 5 negative, a photograph would be a bit fuzzy blown up to this size. The paintings are crisp and sharp. I think with painting it's a problem of selection and imitation, but it's never a problem of creation. It's wrong to think that anyone ever creates. At best one selects new imagery. I can select what to do or not to do from what's in the photograph. I can add or subtract from it. Every time I do something it's a choice, but it's not a choice involving something creative or reproductive. It's a selection from the various aspects of reality. So what I'm trying to paint is not something different, but something more like the place I've photographed. Somehow the paint and the intensity of color emphasize the light and do things to build up form that a photograph does not do. In that way the painting is superior to the photograph. I think that for figures it would be better not to use photographs. There's far more information if you have the person sitting there. You really don't know what a person looks like from a photograph. The reason I take a lot of photographs is to make up for the fact that one photograph really doesn't give me all the information I need. Also, the camera is like one eye and it really deals only with values. And painting is trickery, because you can make people respond by guiding their eyes around the picture. The photograph doesn't do that because a camera doesn't have ideas. It can only reproduce, so you have to use a lot of trickery.

Arthur: A car, a bus, or a lightpost is placed compositionally to move the viewer through the painting?

Estes: For order—and simply to be understandable. Picasso said that all art is a lie. Trickery and lies. I think the thing about the Abstract Expressionists was that they were so involved with pure feeling and emotions that they didn't bother with craftsmanship. There was no urge to just make something beautiful. The great artists of the past never let their feelings or personalities intrude that much. What they were really like doesn't come out in the work. What kind of man was Shakespeare, or Beethoven, or even Rembrandt? There's every point of view except his own, really.

Arthur: Yes, we never know where Shakespeare is in his work. He remains invisible. I've also felt that way about Vermeer.

Estes: Vermeer. Exactly. You have no idea what sort of person he was, except that he was very observant, obviously. He used a machine to do his drawing, I'm sure.

Arthur: Yes, a camera obscura.

Estes: Because his perspective is exaggerated—it is very photographic.

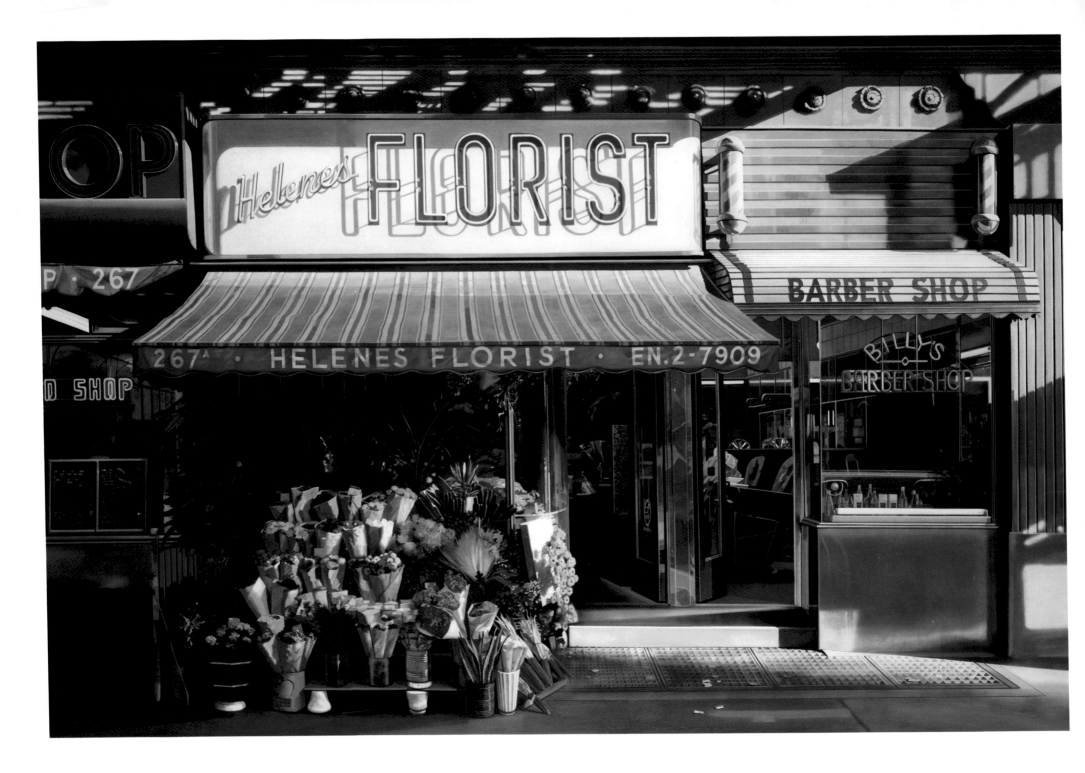

10 *Helene's Florist*, 1971

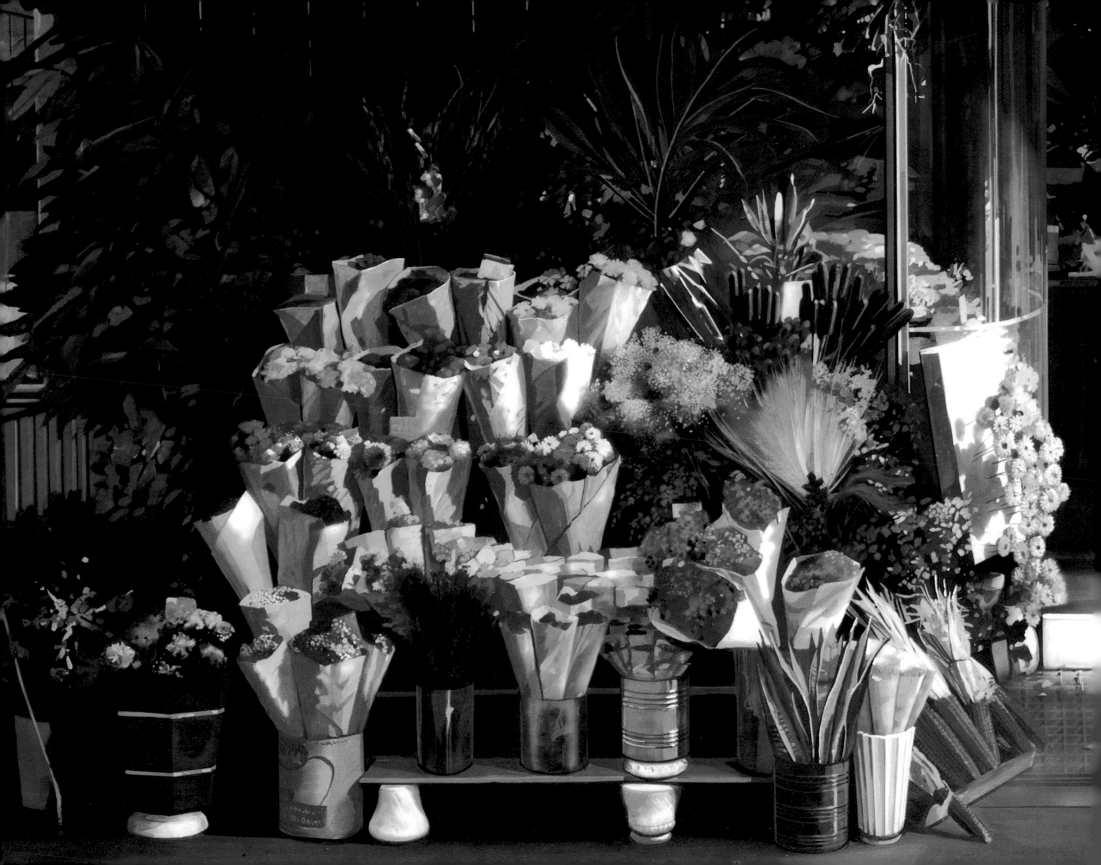

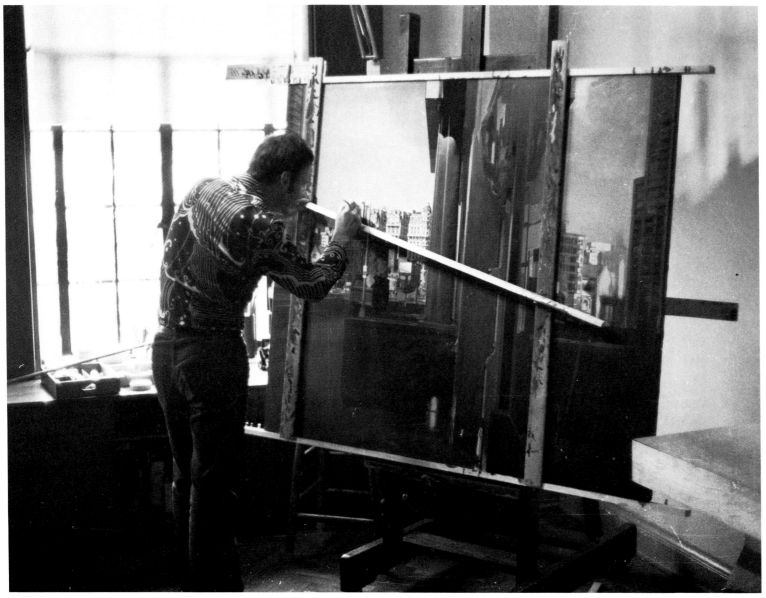

Photograph by George Nick.

Richard Estes at work on *Ansonia* (cat. no. 21).

Arthur: Richard, I'd like to discuss the way your paintings are developed, beginning with the photographs. Do you go out and shoot photographs at random and then comb through the contact sheets to select an image, or do you see something in particular that interests you and return to that place to take the photographs?

Estes: No, I usually just shoot at random. If I find something that is particularly interesting in the contact sheets later on I sometimes go back and rephotograph it.

Arthur: There must be literally thousands and thousands of photographs you've taken by now.

Estes: I'm sure there are.

Arthur: And only a very small portion of them wind up as paintings.

Estes: Yes.

Arthur: With this painting *Downtown,* you went back and took additional photographs.

Estes: Yes, I took the first photographs a long time ago.

Arthur: How long ago?

Estes: Oh, about five years ago.

Arthur: You're kidding. When you returned had the place changed?

Estes: Yes. Actually, in the first photographs that was not a "Beef & Brew Restaurant"; it was a Chinese restaurant. I think it went out of business a couple of years ago.

Arthur: So you've been back recently to take more photographs.

Estes: Yes, just a couple of weeks ago.

Arthur: For this painting *Downtown,* in addition to the large photographs, you have the contact sheets. There must be sixty or seventy details.

Estes: Well, there are about six rolls of 120 film with twelve exposures each, plus the three 4 x 5s. So that's seventy-five to be exact. I won't use all of them. They're in case of an emergency.

Arthur: There must have been a change in the light and time of day when you returned.

Estes: I don't remember the time of day. This is afternoon I believe. Some days have been sunny, others have been rather cloudy. In a way I'm sort of limited to Sundays in New York. There's too much traffic during the week. I work from a tripod with a 4 x 5 camera. I get set up and somebody pulls up and parks a car right in front of me. So I really have to photograph on Sundays. It's impossible any other time. I wait for a good Sunday, when it looks like a really beautiful day with sun and fluffy clouds. I have to drop everything and go out to photograph because I may not get another Sunday like that for months.

Arthur: Then you do your own color printing.

Estes: Yes.

Arthur: What are the circumstances when you decide to do a small gouache, and are they really gouaches, or acrylic on paper?

Estes: It's everything: acrylic, designer's gouache, egg tempera, and oil paint. I use whatever I have. I've been using it improperly, you know. You can get anything to go on paper. It's just a matter of doing it.

Arthur: How much does the image dictate the scale? Is that important?

Estes: No, it really isn't a factor. Everything hits the eyeball the same size. If it's small then you walk up closer.

Arthur: Well, how do you arrive at the scale? For instance, how did you decide that *Downtown* should be a large painting?

Estes: It could have been small, you know. It's just that I felt like doing a big picture. I like big pictures and I like little pictures. It's just what I feel like doing at the time. I could have done this as a small picture.

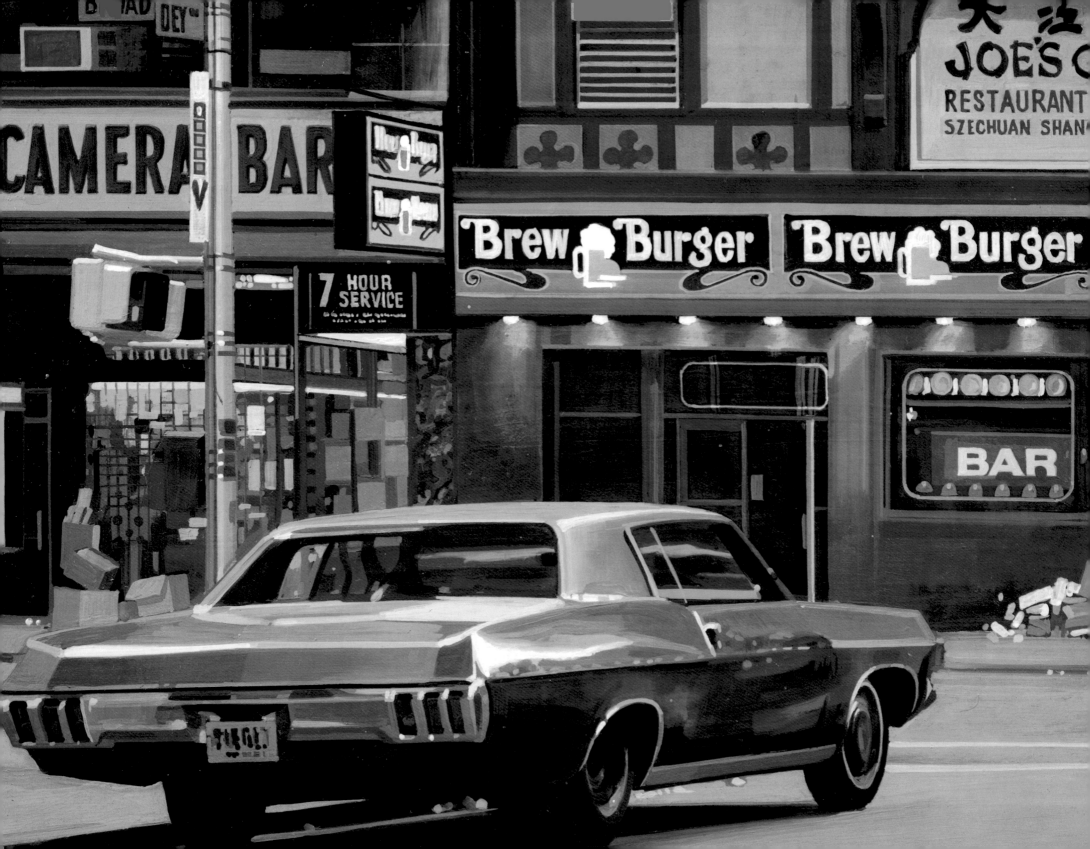

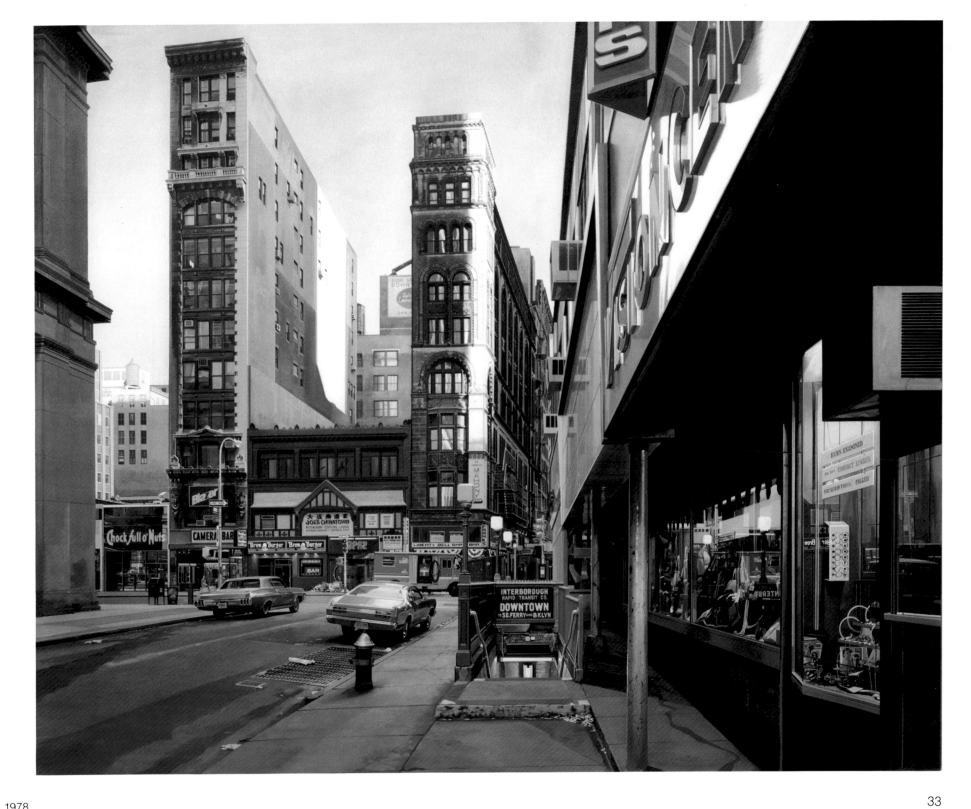

22 *Downtown,* 1978

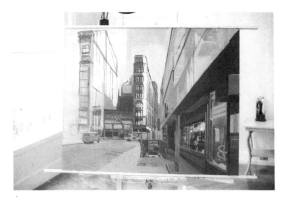

in progress

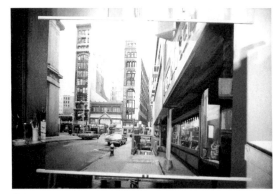

finished painting

Downtown (cat. no. 22) as it appeared in progress in September 1977 and at completion in the spring of 1978.

in progress

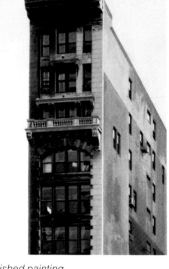

finished painting

in progress

finished painting

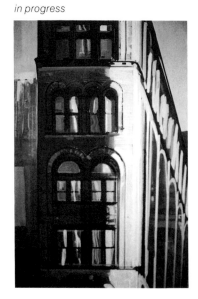

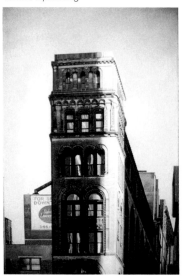

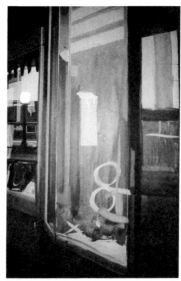

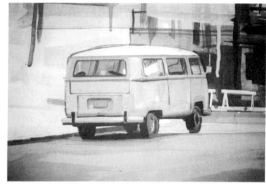

in progress *in progress* *in progress*

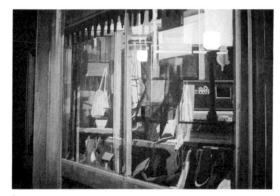

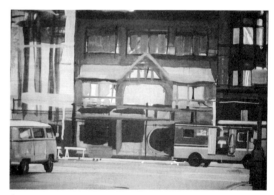

in progress *in progress* *in progress*
finished painting *finished painting* *finished painting*

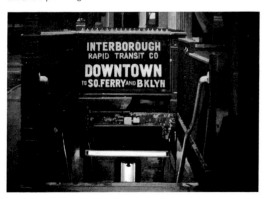

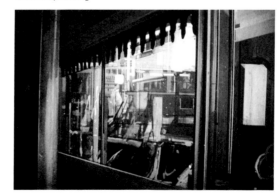

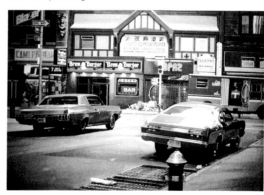

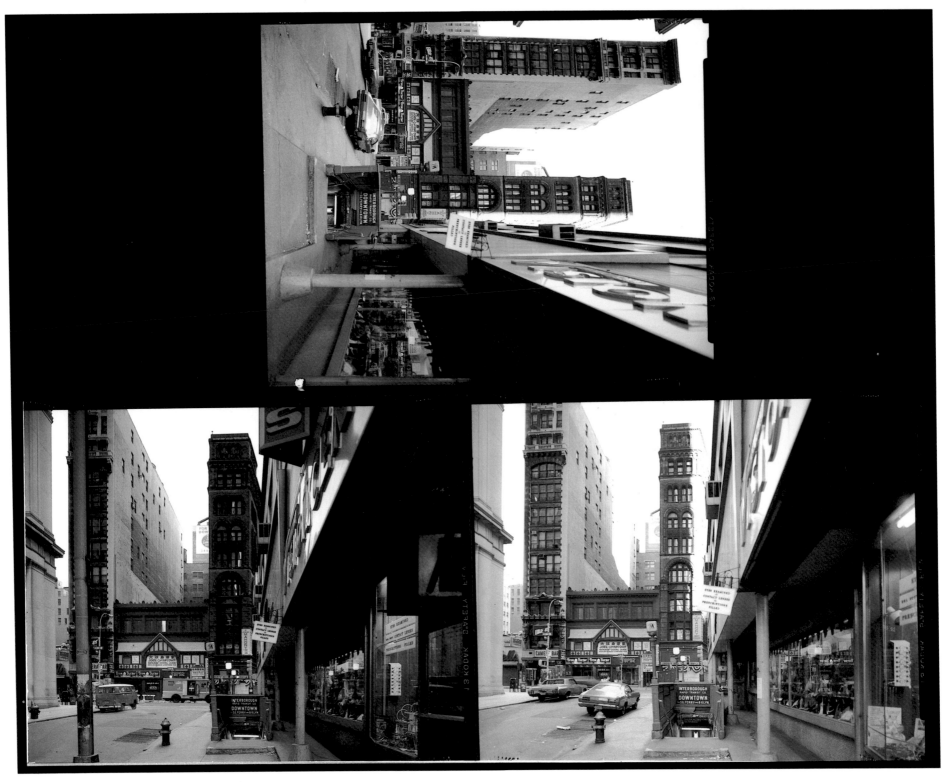

Estes photographs on which *Downtown* (cat. no. 22) is based.

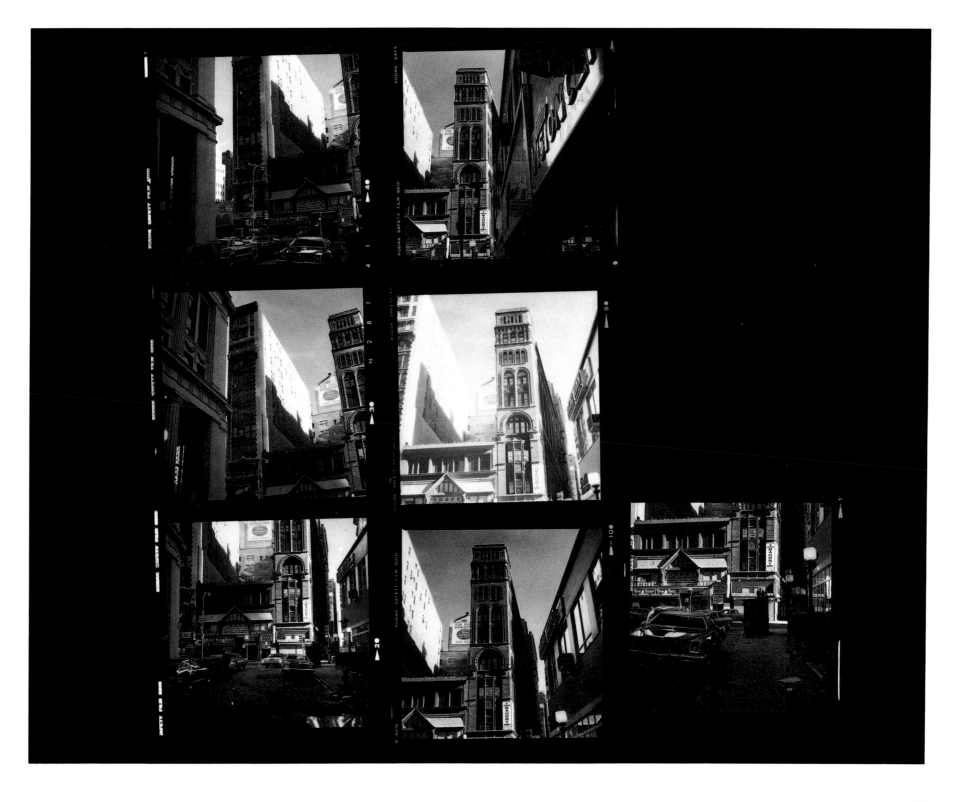

There was no particular reason to do this specific painting big, except that I happened to feel like doing this subject and a big painting at the same time.

Arthur: For *Downtown* there is a large photograph that is very similar to the composition of the painting. But, for instance, the light on the tall building in the center is from a different photograph made at a different time of day.

Estes: Right.

Arthur: So you go through the contact sheets and select details from various photographs. The painting is a composite of many photographs. Also, the perspective of the street behind the subway entrance has been changed and the height of the building in the center has been modified in relation to the other buildings.

Estes: Yes. We're looking at an underpainting, and I may go right back to where I put it before—but probably I won't.

Arthur: Isn't there more than one line of horizon and a shifting in the vanishing points?

Estes: Yes, but there is in the photograph, too, because the streets go in different directions. I find that a certain diagonal helps strengthen the illusion of perspective, a certain angle that really looks deep. Other angles are less deep. It has to look right; I can't think of any rules that I follow.

Arthur: So there's no fixed line of horizon?

Estes: No, because we don't see that way. When you look at a scene or an object you tend to scan it. Your eye travels around and over things. As your eyes move the vanishing point moves, so to have one vanishing point or perfect camera perspective is not realistic.

Arthur: You've got a wooden bar nailed to the top and bottom edge of the canvas that protrudes at the ends, and other devices that you use for the linear perspective, right?

Estes: Well, with a T-square it serves the same purpose as a maulstick. When I'm working in oils I need something to rest my hand on because the paint is wet. I need a firm support for my hand about a quarter of an inch off the canvas. It's also like a T-square, so when I'm doing parallel lines they're all parallel.

Arthur: Do you size your own canvas?

Estes: Yes, with Liquitex Gesso.

Arthur: With this one you've stained the canvas a light tan.

Estes: This one I did. I actually don't do that very often, but everything tends to be very dark in this picture. It's easier to pick out a few highlights with white rather than try to paint everything dark.

Arthur: From seeing only finished works, I—and probably most people—assumed that the paintings are built on a fairly rigid, architectonic drawing. The first real clue I had as to how much you change things around was your painting *B & O,* for the "America 1976" exhibition. After we had the transparency made for the catalogue, you modified the painting considerably, such as adding the yellow car.

Estes: There was a deadline. I wasn't finished though.

Arthur: The reflection in the window changed and the light posts were moved around; you even changed the type of light post. Are such changes typical? Does that happen in most of the paintings?

Estes: It happens a lot. It's just a matter of making things hold together better.

Arthur: Then obviously your primary concerns are not a matter of making the painting look exactly like the place or the photograph?

Estes: Not if that involves making a bad painting. If I have to choose between authenticity and making a good painting, I'd rather have a good painting. I try to make it as accurate as I can, but I usually have to do otherwise, or it just doesn't look right or feel comfortable.

Arthur: Do you ever improvise? Can you make up such elaborate detail?

Estes: Yes. For example in the *Cafeteria* painting there are bright red curtains on each side of the window; that was not in the photographs. I felt that the window was very boring and I had to do something so I just threw in those red curtains, just made them up. In this painting *(Downtown)* I'm going to have to make up the light on the side of the middle building. In the photographs that side is in shadow.

Arthur: The basic drawing is blocked in with diluted acrylic—an umber—it's very loose, just the general outlines. From that you block in some of the lights and darks, but the painting is very broad.

Estes: I find it easier to get the overall effect first, the big areas, then work down into smaller and smaller areas. In that way I'm in control of the painting all of the time. I can't finish everything individually; it has to be finished all at the same time.

Arthur: So after the umber wash drawing you begin to develop the painting in acrylic…working from very broad, loose painting to fairly tight details. As the painting gets more specific you begin to bring the color in. The color and tonality is very closely controlled; isn't that right?

Estes: Yeah, I try to take it as far as I can with the acrylics, but at a certain point it's easier to go into oil paint, which has a greater depth and range of colors, so it's not that the colors and values are finalized; its a matter of relationships. To make that area look like sunlight I have to adjust certain values and contrasts.

Arthur: How reliable is the color in your photographs? You've said that the color in the shadows is a problem.

Estes: One reason I like to make my own color prints is that I can print one for the shadows and another one for the highlights. That way I have my shadow details and highlight details, but there is a great deal of contrast so it's impossible to get all of the detail in the same print.

Arthur: There are a couple of areas, such as the reflection in the window, that are more developed than other parts of the painting. The building on the left side is still a wash drawing. It has been moved back and forth several times. The height of the building in the center has been changed and it's at a slightly different angle from the photographs. Is this a formal or aesthetic adjustment?

Estes: Yes. I try not to do it too much. It's a matter of balancing the painting so that all of the parts are of equal interest and importance.

Arthur: Giving each part of the painting equal attention—we don't really see that way; for instance when we focus on a reflection in a window, we don't see what's inside the window. We tend to focus on layers of space; you paint each layer in equal focus.

Estes: Well, you don't see everything at once. When you look at a room, an object, or a person, you look at different parts and the brain puts it all together as a picture. Whistler said that nature copies art, and, in a way, people don't see things until they're shown. A lot of people have said they never noticed any of this until they saw my paintings. They've lived in New York all their lives and it's always been there, but people simply didn't see it because their eyes were not attuned to it. People found the Impressionist paintings very shocking when they first saw them because the color wasn't what they were accustomed to seeing. Now, with color photography, we find that the Impressionists were absolutely right. But at that time the public was walking around in a brown haze.

Arthur: Of course our perception or reaction to the world around us is continually altered by the arts and sciences. I've passed store fronts and windows in Boston and New York and found myself saying, "That looks like a Richard Estes painting."

Estes: And yet many of the critics dismissed realism more than twenty years ago. They decided that there wasn't anything left to paint realistically; therefore it was the end of the line. It's not that there wasn't anymore left to paint; it was simply that they didn't have the imagination to see that there was a lot.

Arthur: But historically, particularly in American art, the realist tradition has never been broken: Copley, Audubon, Homer, Eakins, Sheeler, and Hopper—and Fairfield Porter and Georgia O'Keeffe working simultaneously with the abstract painters.

Estes: You wouldn't have known that from reading the art magazines or going to most of the serious galleries in the '60s. At that time the general impression was that there was something inferior about painting realistically.

Arthur: You once said that we were taught that to work figuratively or realistically wasn't quite as creative or imaginative as abstract painting.

Estes: I think the problem with most abstract painting is that it's aesthetically boring. The abstract quality of reality is far more exciting than most of the abstract painting that I see. There's got to be a little bit of struggle—some areas not really working, certain imperfections showing. The problem with someone like Kenneth Noland is that there's no apparent struggle. It's too simple, too easy. It's like music by Mantovani.

Arthur: To move back to a technical question: there comes a point with the acrylic when you have the detail and the color developed as far as you can, and then you shift to oil. The changes that occur with oil seem to be primarily a matter of subtleties. If this painting were photographed when the acrylic underpainting was finished, it would look—certainly in a black and white photograph—like a finished painting. Isn't that right?

Photograph by George Nick.

Richard Estes at work on *Ansonia* (cat. no. 21).

11 *People's Flowers*, 1971

Estes: It would look more crude, but basically it would be the same painting. The oil gives a greater depth and more control of the gradations of color, blending for example. It's a much richer look than acrylic. Acrylic is easier to work with; it's good for underpainting and dries quickly, so it's easy to make big corrections. With oil you have to know pretty much what should be there because of the differences in the characteristics and drying times of the colors.

Arthur: Do you separate the acrylic underpainting from the oil with a varnish?

Estes: No.

Arthur: What medium do you use with the oil?

Estes: Recently, I've been using "Wingel." It's a medium that dries fairly quick and when I draw a line it won't bleed out. For instance, if I'm painting into a wet oil, and put a line in, the line will just start spreading and is very hard to control. So this medium allows me to get fairly sharp detail with wet paint and it won't run. That seems to be the main advantage.

Arthur: I noticed in the painting *Candy Store,* you had originally used "Day-glo" paint, which has begun to crack and fade.

Estes: Yes. I used it for the neon signs, but it faded. I've found that a good cadmium red is just as bright as the "Day-glo" and the cadmium won't fade, so that's being corrected.

Arthur: The acrylic underpainting, even in a large painting such as this one, seems to go surprisingly fast. You said it would take about a week to finish this part.

Estes: I can easily do the underpainting in a week and then spend two months on the oil overpainting. Yet the painting looks finished after a week. It's just polishing, getting the quality.

Arthur: One thing that would seem to be difficult when you're spending three or four months on a painting is sustaining the interest and enthusiasm for such a long period.

Estes: I think the popular concept of the artist is a person who has this great passion and enthusiasm and super emotion. He just throws himself into this great masterpiece and collapses from exhaustion when it's finished. It's really not that way at all. Usually it's a pretty calculated, sustained, and slow process by which you develop something. The effect can be one of spontaneity but that's part of the artistry. An actor can do a play on Broadway for three years. Every night he's expressing the same emotion in exactly the same way. He has developed a technique to convey those feelings so that he can get the ideas across. Or a musician may not want to play that damn music at all, but he has a booking and has to do it. I think the real test is to plan something and be able to carry it out to the very end. Not that you're always enthusiastic; it's just that you have to get this thing out. It's not done with one's emotions; it's done with the head.

Arthur: But don't you ever reach a point, after spending months on a painting, of looking at it and saying, "My God, is it really worth this much effort?" Aren't there paintings that you get bored with before they're finished?

Estes: Actually, it's been my experience that the paintings I've hated working on the most and have gotten the most bored with, really feeling were terrible while working on them, have ended up being my best paintings. The ones that I've had a real enthusiasm for, a real feel for, I thought they were masterpieces at the time but realize they are duds six months later.

Arthur: Yesterday we were discussing the blandness and austerity of most contemporary architecture. You find the actual buildings aesthetically boring and yet these stainless steel and glass façades have provided the source material for some of your best paintings. The other extreme is Times Square with its neon, movie theaters, and massage parlors, but the most banal and garish aspects of the urban landscape seem to provide the grist for your paintings.

Estes: Paintings of ugly things are more successful than paintings of beautiful things. A classic example is Goya's *Third of May,* or Géricault's *Raft of the Medusa.* Neither would have been a pleasant sight to behold.

Arthur: But both are narrative paintings with social and political ramifications.

Estes: What about Diane Arbus? Her photographs are beautiful, but disturbing. They're certainly not photographs of beautiful people and yet they are not grotesque photographs. In painting, music, or literature there are qualities more important than prettiness. Beethoven didn't write pretty music. It's rather ugly music, like Wagner.

Arthur: Like van Gogh's *Potato Eaters.* We wouldn't want to join them for dinner. We both admire Art Deco architecture, and there are great examples in New York, such as the Chrysler Building, the old R.C.A. in Rockefeller Plaza, and the Fuller Building on 57th Street, and yet you've never painted one of them.

Estes: Well, I haven't stopped painting yet. Eventually, I'll get around to it if they don't tear them down.

Arthur: I know you've repainted *Bus Window* and parts of the *Automat.* Do you often see old paintings that you wish you could rework?

Estes: Oh yes. In the process of having painted steadily now for about ten years, each year I get a little more adept. It becomes easier and the paintings are more refined. I see a lot of the early paintings that look very unfinished. That's the main thing, not that I would change things that much. I would just get rid of a lot of the blotches, sharpen things up, adjust the values, get rid of the flatness, so that there's a little more sparkle, a little more depth. I can see when it's going to stop. I can hear it too, when it goes click.

That click is perceptible only to Richard Estes.

The modification of a reflection, a shift in the position of a lightpost, or removal or addition of an automobile are changes too subtle to substantially alter one's response to the paintings. They are prompted by the painter's own intuitive sense of balance and tension and obviously cannot be regarded as simply a confirmation of veracity or recording of fact.

In the end, we are awed by much more than verisimilitude.

J.A.

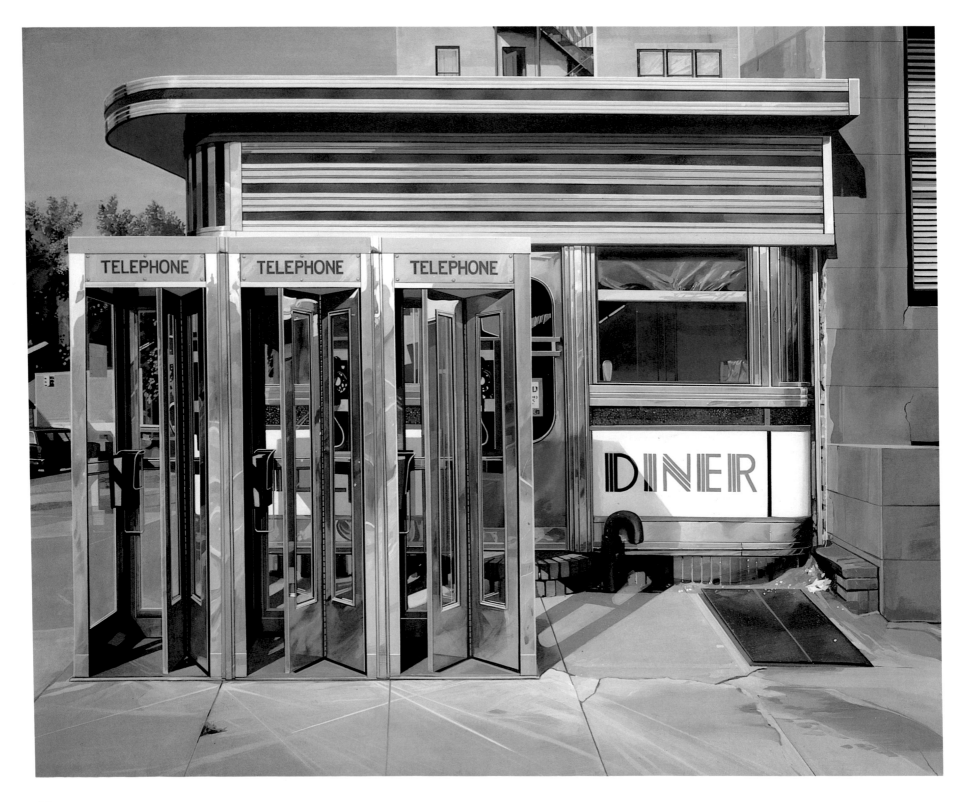

12 *Diner*, 1971

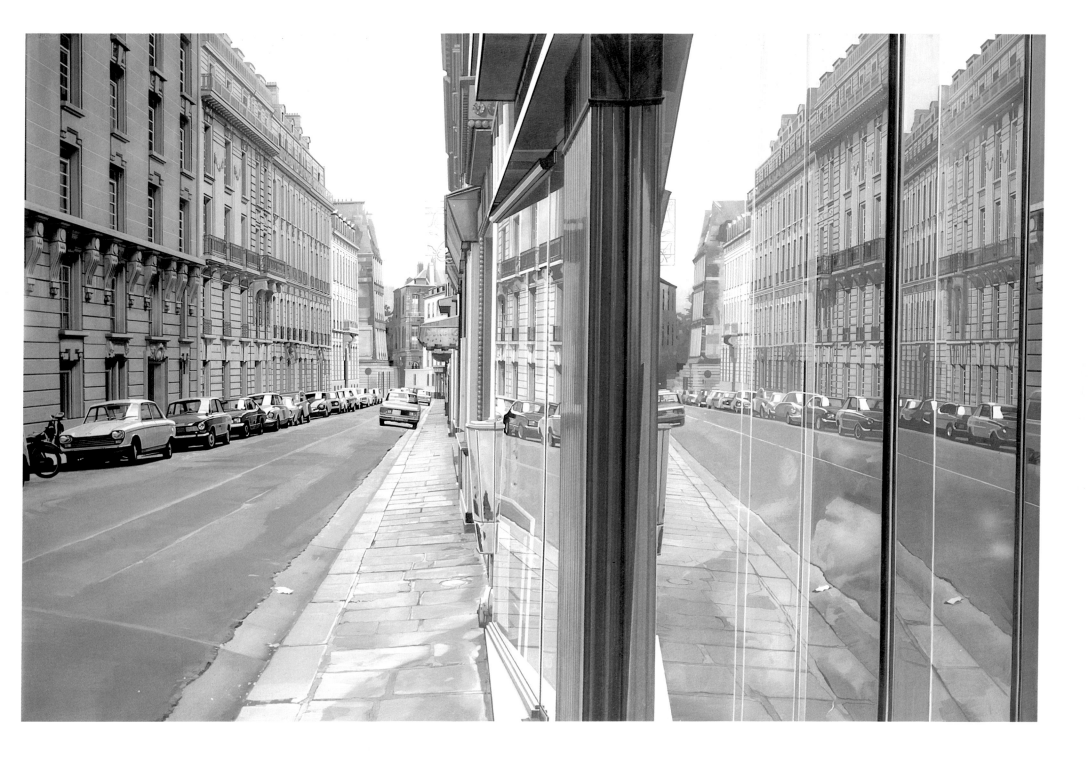

13 *Paris Street Scene*, 1972

1936	Born Kewanee, Illinois Lived in Evanston, Illinois
1952–1956	Studied at the Art Institute of Chicago
1956–1966	Worked in publishing and advertising, doing illustrations and layout
1959	Moved to New York City
1962	Lived and painted in Spain for a year
1966	Began to paint full-time
1968	First solo exhibition at Allan Stone Gallery
1971	$2,500 fellowship award from the National Endowment for the Arts "Urban Landscapes," a portfolio of eight silkscreen prints, published by Parasol Press, New York. Printed by Domberger, Stuttgart, in an edition of 75.
1972	Summer. Visiting Artist for a weekend at the Skowhegan School, Skowhegan, Maine
1975	Untitled (Qualicraft Shoes) large silkscreen print (35¾ x 49¼ in.), published by Parasol Press, New York. Printed by Domberger, Stuttgart, in an edition of 100.
1978	Richard Estes lives and works in New York City and in Maine.

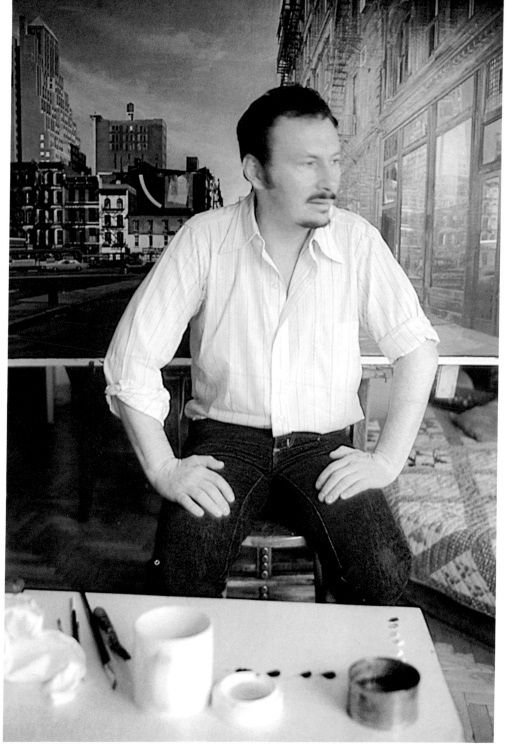

Photograph by Michael Lutch. Courtesy of *Horizon* Magazine.

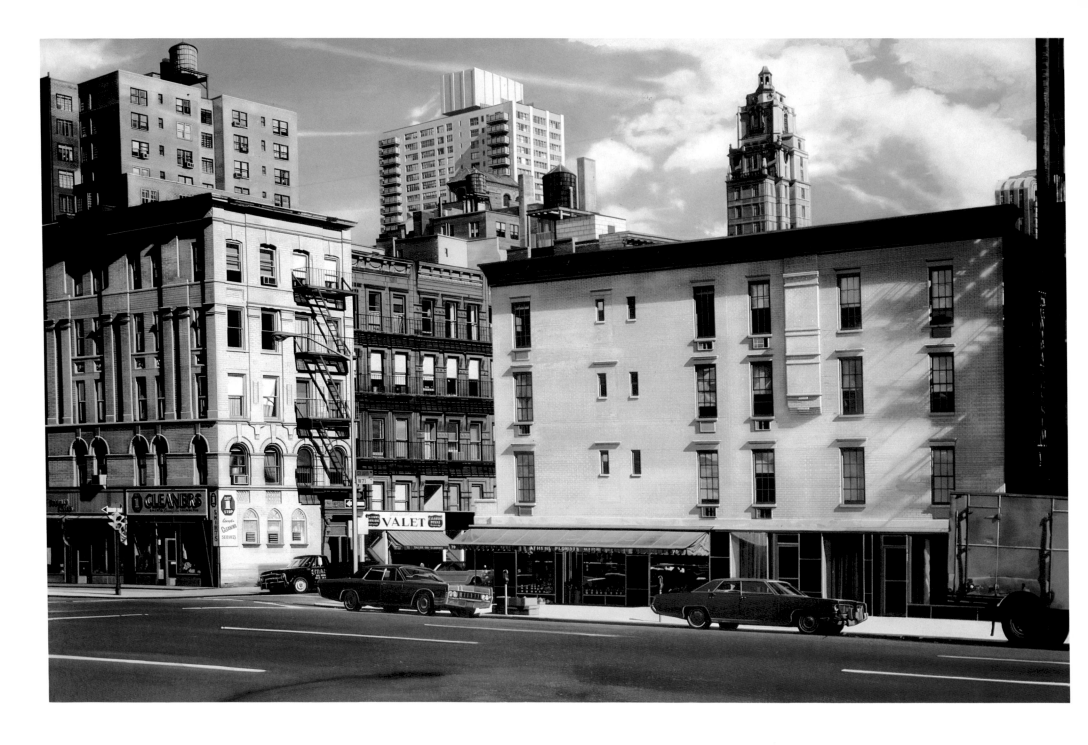

14 *Valet*, 1972

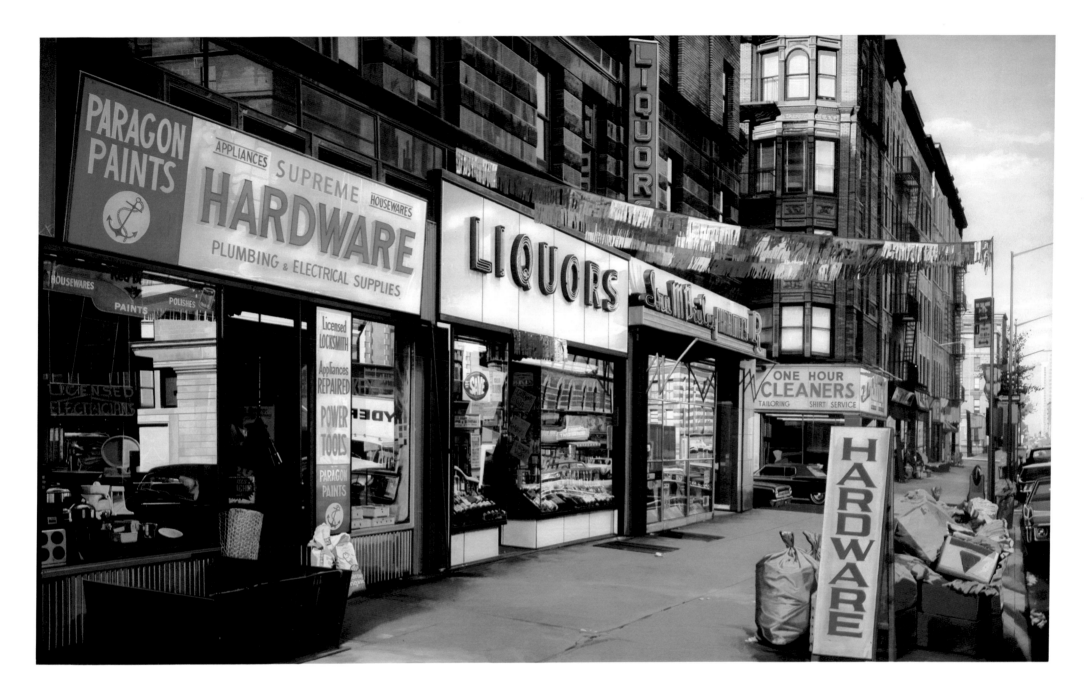

15 *Supreme Hardware Store*, 1973

BIBLIOGRAPHY

Alliata, Vicky. "American Essays on Super-realism." *Domus* no. 536 (1974), pp. 52–54, illus.

Anonymous. "Super Realism." *Life* 66, no. 25 (June 27, 1969), pp. 44–50A, illus.

—. "Hockey's Muted Moments." *Sports Illustrated* 31, no. 19 (November 3, 1969), pp. 28–33, illus.

Art in America 60, no. 6 (November–December 1972). Special issue on Super Realism, illus.

Arts 48, no. 5 (February 1974). Special issue on Super Realism, illus.

Battcock, Gregory, ed. *Super Realism: A Critical Anthology.* New York: E. P. Dutton, 1975, illus.

M.B. (Benedikt, Michael). "Reviews and Previews." *Art News* 68, no. 1 (March 1969), p. 17.

G.B. (Brown, Gordon). "Arts Reviews." *Arts* 51, no. 10 (June 1977), p. 48, illus.

M.B. (Brumer, Miriam). "In the Galleries." *Arts* 43, no. 4 (February 1969), p. 58, illus.

Burton, Scott. "Generation of Light, 1945–1969." *Art News Annual* 35 (*Light from Aten to Laser.* Edited by Thomas B. Hess and John Ashbery). New York: Newsweek, Inc., 1969, pp. 20–23, illus.

Butler, Joseph T. "America" ["Three Realists: Close, Estes, and Raffael"]. *Connoisseur* 186, no. 748 (June 1974), p. 143.

L.C. (Campbell, Lawrence). "Reviews." *Art News* 73, no. 7 (September 1974), p. 114.

Canaday, John. "A Critic's Valedictory: The Americanization of Modern Art and Other Upheavals." *New York Times,* August 8, 1972; Section 2, pp. 1, 23, illus.

—. "Realism: Waxing or Waning?" *New York Times,* July 13, 1969; Section 2, p. 27, illus.

Chase, Linda. "Photo-Realism: Post Modernist Illusionism." *Art International* 20, nos. 3–4 (March-April 1976), pp. 14–27, illus.

—; Foote, Nancy; McBurnett, Ted. "The Photo-Realists: 12 Interviews." *Art in America* 60, no. 6 (November–December 1972), pp. 58–72, illus.

Clay, Julien. "Réalité et fantasme de la ville." *XXᵉ siècle,* no. 45 (December 1976), pp. 78–81, illus.

Constable, Rosalind, "Style of the Year: The Inhumanists." *New York Magazine* 1, no. 37 (December 16, 1968), pp. 44–50, illus.

Cummings, Paul. *Dictionary of Contemporary American Artists*. 3d ed. New York: St. Martin's Press, 1977, pp. 182–183, illus.

Davis, Douglas. "Return to the Real." *Newsweek* 75 (February 23, 1970), p. 105.

Gassiot-Talabot, Gerald. "Le Choc des 《 Réalismes 》." *XXᵉ siècle*, no. 42 (June 1974), pp. 25–32, illus.

Hemphill, Chris. "Estes." *Andy Warhol's Interview* 4, no. 11 (October 1974), pp. 42–43, illus.

Henry, Gerrit. "The Real Thing." *Art International* 16, no. 6 (Summer 1972), pp. 87–91, 194, illus.

Hickey, Dave. "New York Reviews." *Art in America* 60, no. 2 (March–April 1972), pp. 116–118.

Karp, Ivan. "Rent is the Only Reality, or the Hotel Instead of the Hymns." *Arts* 46, no. 3 (December–January 1972), pp. 47–51, illus.

Kelley, Mary Lou. "Pop-Art Inspired Objective Realism." *Christian Science Monitor*, April 1, 1974, p. 48, illus.

Kramer, Hilton. "And Now…Pop Art, Phase II." *New York Times*, January 16, 1972; Section 2, p. D19.

Kultermann, Udo. *New Realism*. Greenwich, Conn.: New York Graphic Society, 1972, illus.

K.L. (Levin, Kim). "Reviews and Previews." *Art News* 67, no. 1 (April 1968), p. 12.

E.L. (Lubell, Ellen). "In the Galleries." *Arts* 46, no. 7 (May 1972), pp. 67–68.

Lucie-Smith, Edward. *Late Modern: The Visual Arts Since 1945*. New York and Washington: Frederick A. Praeger, 1969, pp. 251–252, illus.

___. "Realism Rules: O.K.?" *Art and Artists* 11, no. 6 (September 1976), pp. 8–15.

___. "The Neutral Style." *Art and Artists* 10, no. 5 (August 1975), pp. 6–15.

Marandel, J. Patrice. "The Deductive Image." *Art International* 15, no. 7 (September 20, 1971), pp. 58–61, illus.

C.N. (Nemser, Cindy). "In the Galleries." *Arts* 44, no. 7 (May 1970), p. 60, illus.

S.N. (Nordstrom, Sherry C.). "Reviews and Previews." *Art News* 69, no. 3 (May 1970), p. 28.

R.O. (Olson, Robert J. M.) "Arts Reviews." *Arts* 49, no. 1 (September 1974), p. 62, illus.

Patton, Phil. *"Super Realism: A Critical Anthology"* (book review). *Artforum* 14, no. 5 (January 1976), pp. 52–54, illus.

Raymond, Herbert. "The Real Estes" (interview). *Art and Artists* (August 1974), pp. 24–29, illus.

Restany, Pierre. "Sharp Focus: La Continuité réaliste d'une vision Americaine." *Domus* no. 535 (August 1973), pp. 9–13, illus.

Rose, Barbara. "Treacle and Trash." *New York Magazine* 7, no. 21 (May 27, 1974), pp. 80–81.

Rosenberg, Harold. "Reality Again." *New Yorker* 47 (February 5, 1972), pp. 88–93.

Russell, John. "An Unnatural Silence Pervades Estes Paintings." *New York Times*, May 25, 1974, illus.

Sager, Peter. *Neue Formen des Realismus*. Cologne: M. DuMont Schauberg, 1973, illus.

Schjeldahl, Peter. "The Flowering of the Super-Real." *New York Times*, March 2, 1969; Section 2, pp. D31, D33.

Seitz, William C. "The Real and the Artificial; Painting of the New Environment." *Art in America* 60, no. 6 (November–December 1972), pp. 58–72, illus.

Shirey, David L. "The Gallery: It's Happening Out There." *Wall Street Journal*, April 13, 1969, p. 14.

Stebbins, Theodore E., Jr. *American Master Drawings and Watercolors: A History of Works on Paper from Colonial Times to the Present*. New York: Harper and Row, 1976.

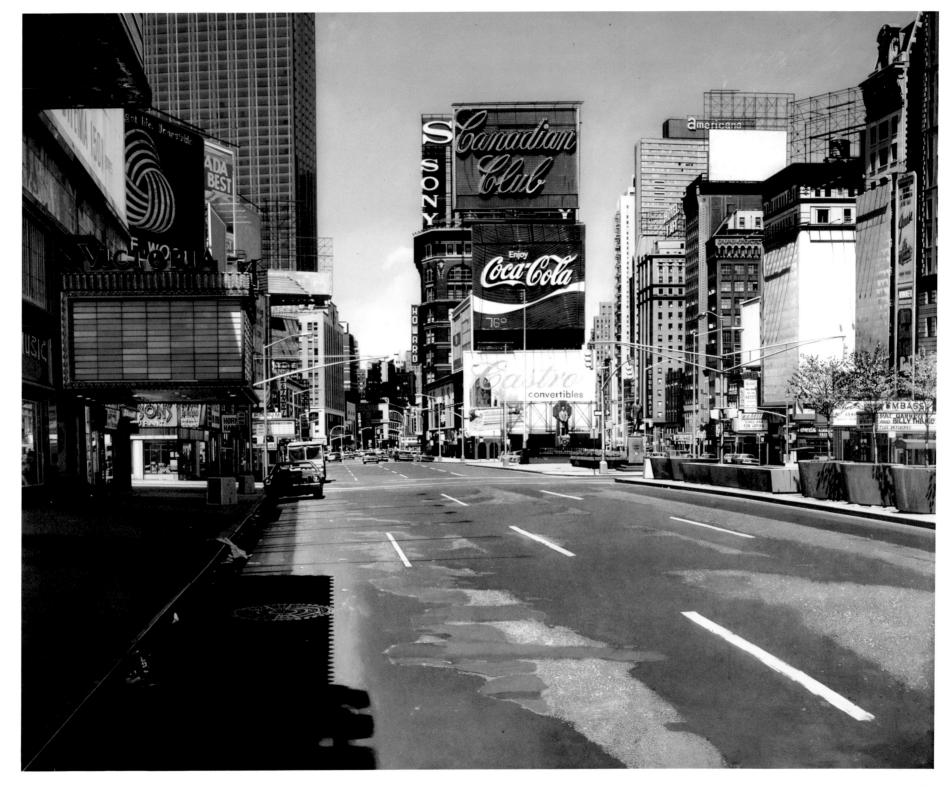

16 *Canadian Club*, 1974

EXHIBITIONS

1968 **February 20–March 9.** First solo exhibition, Allan Stone Gallery, New York

May 8–June 12. "Realism Now," Vassar College Art Gallery, Poughkeepsie, New York

September 15–October 27. "The Wellington-Ivest Collection," Museum of Fine Arts, Boston

November–December. "Richard Estes" (solo exhibition), Hudson River Museum, Yonkers, New York

1969 **February 15–March 7.** Solo exhibition, Allan Stone Gallery, New York

March 2–April 6. "Contemporary American Painting and Sculpture 1969," Krannert Art Museum, University of Illinois, Champaign, Illinois

March–September. "Painting and Sculpture Today," John Herron Museum, Indianapolis

June 21–August 10. "Directions 2: Aspects of a New Realism," Milwaukee Art Center

July–August. "Butler Invited National Mid-Year Show," Butler Institute, Youngstown, Ohio

September 17–October 19. "Directions 2: Aspects of a New Realism," Contemporary Arts Association, Houston

October–December. "American Report on the 60's," Denver Art Museum

November 9–December 14. "Directions 2: Aspects of a New Realism," Akron Art Institute, Akron, Ohio

1970 **December 9 (1969)–February 15.** "Painting from the Photo," Riverside Museum, New York

February. "Whitney Annual," Whitney Museum, New York

February–March. "Centennial Exhibit," Indiana State University, Indianapolis

February 10–March 29. "Twenty-Two Realists," Whitney Museum, New York

February 13–March 11. "New Realism '70," Headley Hall Gallery, St. Cloud State College, St. Cloud, Minnesota

March (?). "Directions '70/Part II: The Cool Realists," Jack Glenn Gallery, Corona Del Mar, California

April 16–May 31. "Cool Realism," Members' Gallery, Albright-Knox Art Gallery, Buffalo, New York

April 18–May 9. Solo exhibition, Allan Stone Gallery, New York

May 4–June 7. "American Painting 1970," Virginia Museum, Richmond

September 10–October 5. "Cool Realism," Everson Museum, Syracuse, New York

1971 January 24–February 20. "Contemporary Selections 1971," Birmingham Museum, Birmingham, Alabama

February–April 4. "32nd Biennial Exhibition of Contemporary American Painting," Corcoran Gallery, Washington, D.C.

May. "Neue Amerikanische Realisten," Galerie de Gestlo, Hamburg

May 22–June 4. "Radical Realism," Museum of Contemporary Art, Chicago

June–August, 1971. "Art Around the Automobile," Emily Lowe Gallery, Hofstra University, New York

1972 January. "New Realism," Lowe Art Museum, Coral Gables, Florida

January. "Whitney Annual," Whitney Museum, New York

January 6–February 5. "Sharp-Focus Realism by 28 Painters and Sculptors," Sidney Janis Gallery, New York

April 8–May 6. Solo exhibition, Allan Stone Gallery, New York

June 11–October 1. "36th International Biennial Exhibition," Venice

June 30–August 20. "70th American Exhibition," Art Institute of Chicago

June 30–August 30. "Documenta and no-Documenta Realists," Galerie de Gestlo, Hamburg

June 30–October 8. "Documenta 5," Kassel

October 25–November 25. "Hyperréalistes Americains," Galerie des quatres mouvements, Paris

December (1972)–January 1973. "The Realist Revival," New York Cultural Center (circulated by the American Federation of Arts)

November 16–December 26. "Amerikanischer Fotorealismus," Württembergischer Stuttgart Kunstverein

1973 January 6–February 18. "Amerikanischer Fotorealismus," Frankfurter Kunstverein

February. "Iperrealisti Americani," Galleria la Medusa, Rome

February 25–April 8. "Amerikanischer Fotorealismus," Kunst-und Museumsverein Wuppertal

April. "East Coast/West Coast/New Realism," California State University Art Gallery, San Jose

April 4–May 6. "Photo Realism," Serpentine Gallery, London

August–October. "American Art: Third Quarter Century," Seattle

September. "Stuart M. Speiser Collection of Photo Realism," Meisel Gallery, New York

November–December. "Stuart M. Speiser Collection of Photo Realism," Johnson Museum, Ithaca, New York

1974 Spring. Solo exhibition, Allan Stone Gallery, New York

January–February. "Stuart M. Speiser Collection of Photo Realism," Memorial Art Gallery, Rochester, New York

March. "Three Realists: Close, Estes, Raffael," Worcester Art Museum, Worcester, Massachusetts

March 9–April 28. Solo exhibition, Museum of Contemporary Art, Chicago

March–April. "Stuart M. Speiser Collection of Photo Realism," Addison Gallery, Andover, Massachusetts

April 10–May 19. "New Photo Realism: Paintings and Sculpture in the 1970's," Wadsworth Atheneum, Hartford

June. "Stuart M. Speiser Collection of Photo Realism," Allentown Art Museum, Allentown, Pennsylvania

August–September. "Stuart M. Speiser Collection of Photo Realism," University of Texas Art Gallery, Austin

September–October. "Stuart M. Speiser Collection of Photo Realism," Witte Memorial Museum, San Antonio

October. "Twelve American Painters," Virginia Museum, Richmond

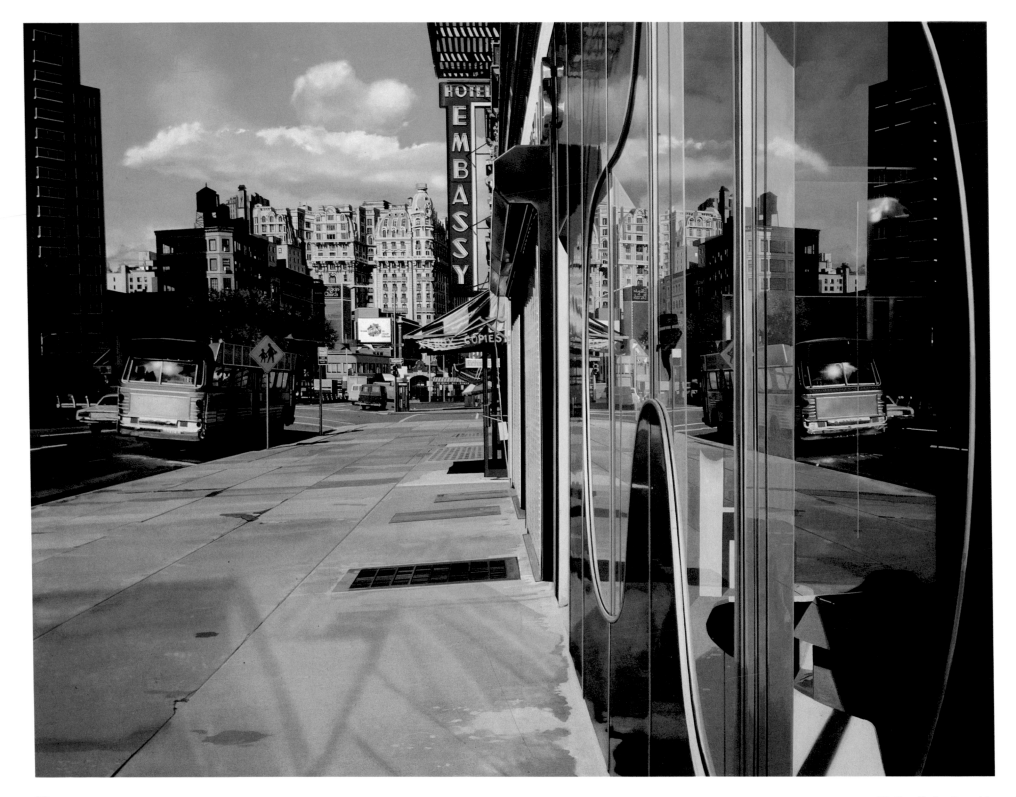

17 *Bus Reflections (Ansonia)*, 1974

1975 January 27–February 9. "Trends in Contemporary American Realist Painting," Museum of Fine Arts, Boston

November 18–January 11, 1976. "Super Realism: An Exhibition," Baltimore Museum

1976 January 17–February 29. "Urban Aesthetics," Queens Museum, Flushing, New York

April 27–June 6. "America 1976," Corcoran Gallery, Washington, D.C.

May–November 7. "America as Art," National Collection of Fine Arts, Smithsonian Institution, Washington, D.C.

June. "Aspects of Realism," The Gallery, Stratford, Canada

June 16–September 5. "A Selection of American Art: The Skowhegan School 1946–1976," Institute of Contemporary Art, Boston

July 4–September 12. "America 1976," Wadsworth Atheneum, Hartford

October 1–30. "A Selection of American Art: The Skowhegan School 1946–1976," Colby College Museum, Waterville, Maine

October–November. "Alumni Exhibition," School of the Art Institute of Chicago

October 19–December 7. "America 1976," Fogg Art Museum, Cambridge, Massachusetts, and Institute of Contemporary Art, Boston

November through 1977. "Illusion and Reality" (circulated by the Australian Council throughout Australia)

November 23–January 23, 1977. "American Master Drawings and Watercolors," Whitney Museum, New York

1977 January 16–February 27. "America 1976," Minneapolis Institute of Arts

March 19–May 15. "America 1976," Milwaukee Art Center

June 18–August 14. "America 1976," Fort Worth Art Museum

September 10–November 13. "America 1976," San Francisco Museum of Modern Art

December 10–February 5, 1978. "America 1976," High Museum, Atlanta

November 22, 1976–March 1, 1977. "New Acquisitions Exhibition," Museum of Modern Art, New York

February 19–April 3. "Whitney Biennial," Whitney Museum, New York

18 *Bridal Accessories*, 1975

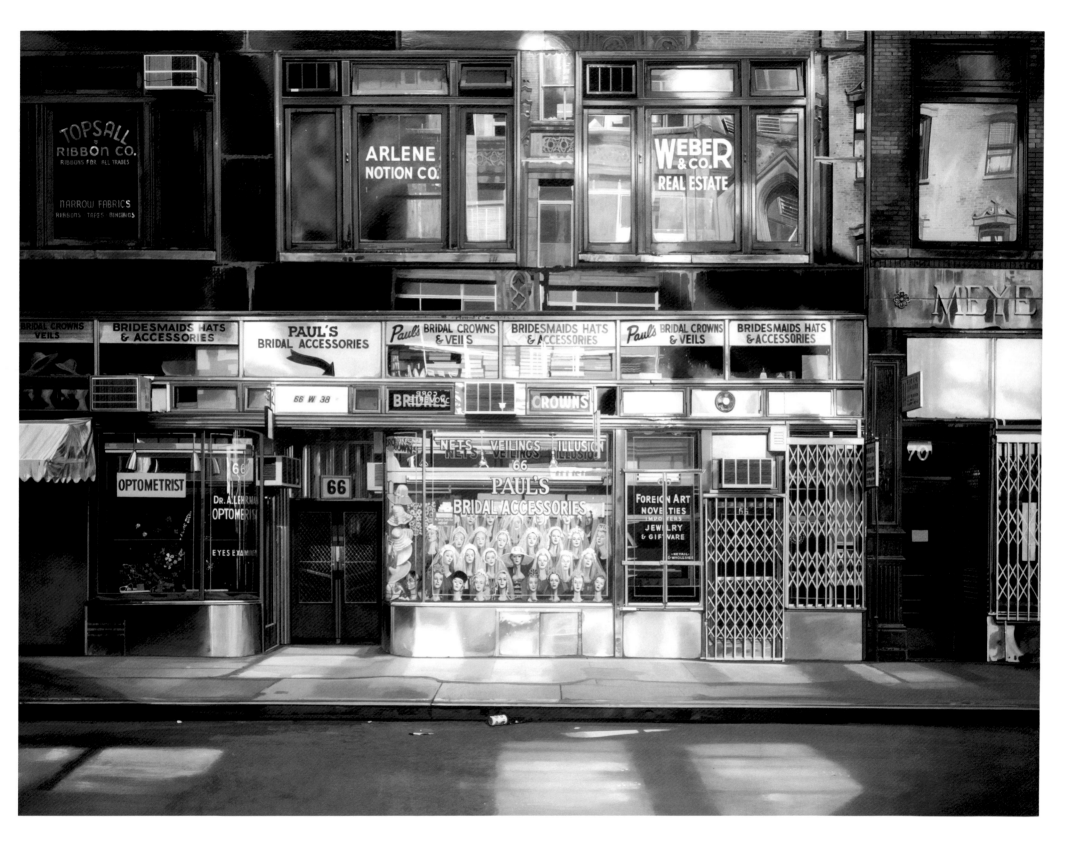

CHECKLIST

1 Untitled (early figure painting), 1965
Oil on canvas, 26 x 34 in.
Allan Stone Gallery, New York

2 *Subway Passengers* (underpainting), 1966
Tempera on masonite, 36 x 48 in.
Richard Estes

3 *Automat,* 1967
Oil on masonite, 60 x 48 in.
Marie C. Estes

4 *Horn and Hardart Automat,* 1967
Oil on masonite, 48 x 60 in.
Mr. and Mrs. Stephen D. Paine

5 *Telephone Booths,* 1968
Oil on canvas, 48 x 69 in.
H. H. Thyssen-Bornemisza Collection

*6 *Candy Store,* 1968–1969
Acrylic, oil, and fluorescent paint on canvas, 47¾ x 68¾ in.
Whitney Museum of American Art, New York; Gift of the Friends of the Whitney
Museum of American Art (69.21)

7 *Bus Window,* 1968–1973
Acrylic and oil on masonite, 48 x 36 in.
Mr. and Mrs. R. A. L. Ellis

8 *Grand Luncheonette,* 1969
Oil on canvas, 51 x 69¼ in.
Acquavella Contemporary Art, New York

**9 *Escalator,* 1970
Oil on canvas, 42½ x 62 in.
Private collection

10 *Helene's Florist,* 1971
Oil on canvas, 48 x 72 in.
Toledo Museum of Art, Toledo, Ohio; Gift of Edward Drummond Libbey

11 *People's Flowers,* 1971
Oil on canvas, 60 x 40 in.
H. H. Thyssen-Bornemisza Collection

12 *Diner,* 1971
Oil on canvas, 40⅛ x 50 in.
Hirshhorn Museum and Sculpture Garden, Smithsonian Institution,
Washington, D.C.

13 *Paris Street Scene,* 1972
Oil on canvas, 40 x 60 in.
Sydney and Frances Lewis

14 *Valet,* 1972
Oil on canvas, 44 x 68 in.
Private collection

15 *Supreme Hardware Store,* 1973
Oil on canvas, 40 x 66¼ in.
Allan Stone Gallery, New York

*16 *Canadian Club,* 1974
Oil on masonite, 48 x 60 in.
Neumann Family Collection

17 *Bus Reflections (Ansonia),* 1974
Oil on canvas, 40 x 52 in.
Paul Hottlet

18 *Bridal Accessories,* 1975
Oil on canvas, 36 x 48 in.
Graham Gund

19 *Central Savings,* 1975
Oil on canvas, 36 x 48 in.
Nelson Gallery-Atkins Museum, Kansas City, Missouri; Friends of Art Collection

20 *Hotel Lucerne,* 1976
Oil on canvas, 48 x 60 in.
H. H. Thyssen-Bornemisza Collection

21 *Ansonia,* 1977
Oil on canvas, 48 x 60 in.
Whitney Museum of American Art, New York; Sydney and Frances Lewis Collection
(77.37)

22 *Downtown,* 1978
Oil on canvas, 48 x 60 in.
Ludwig Collection

23 *Baby Doll Lounge,* 1978
Oil on canvas, 36 x 60 in.
Mr. and Mrs. H. Christopher J. Brumder

 * Nelson-Atkins and Hirshhorn only
** M.F.A. and Hirshhorn only

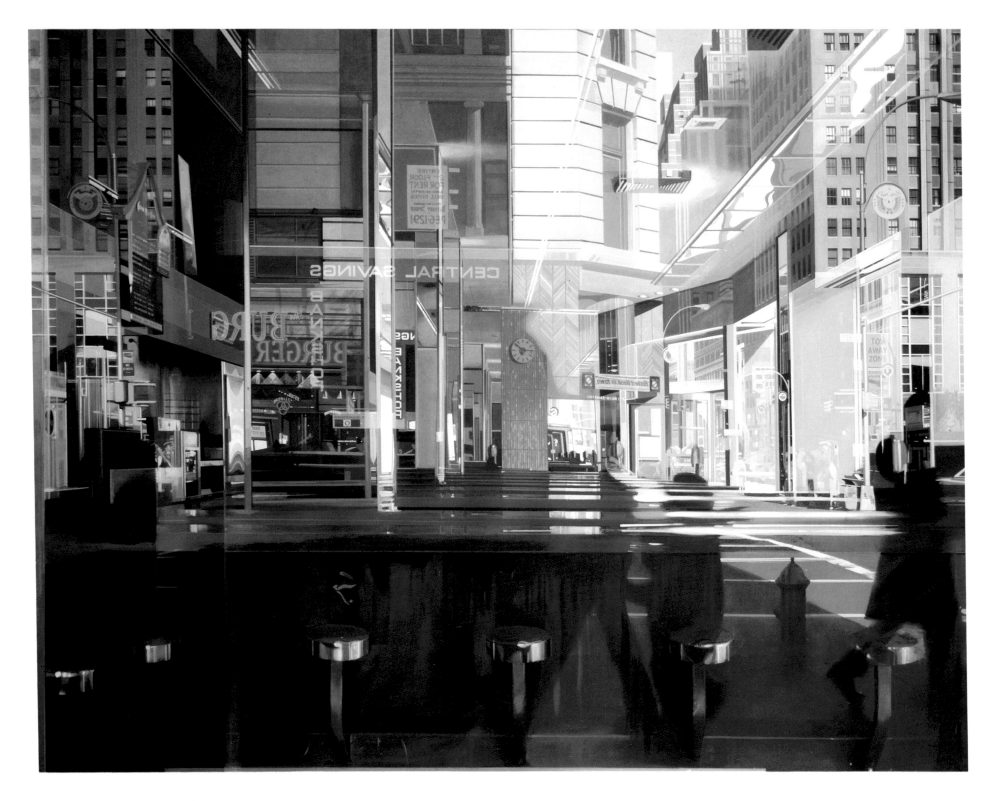

19 *Central Savings*, 1975

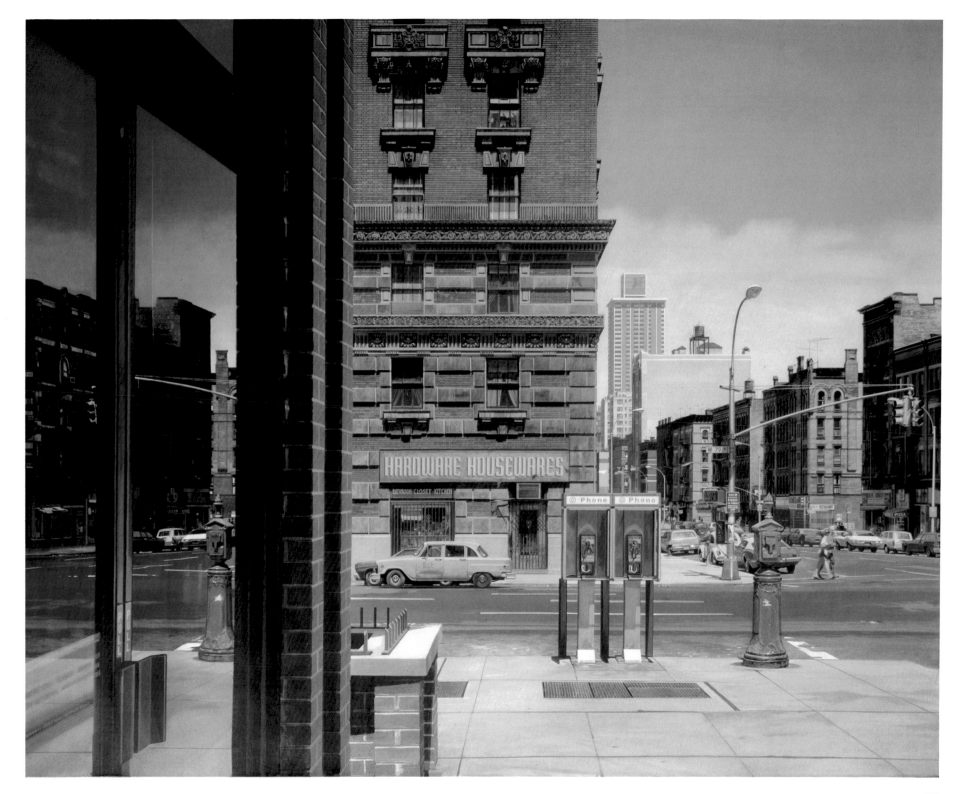

20 *Hotel Lucerne*, 1976

Progressive stages in the development of *Baby Doll Lounge* (cat. no. 23).

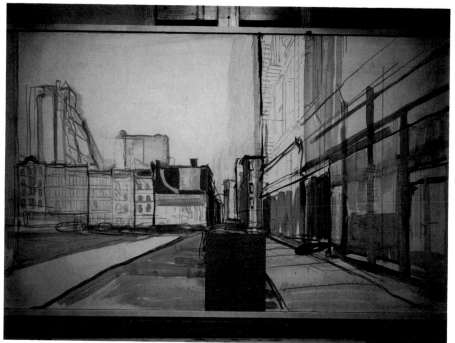

1

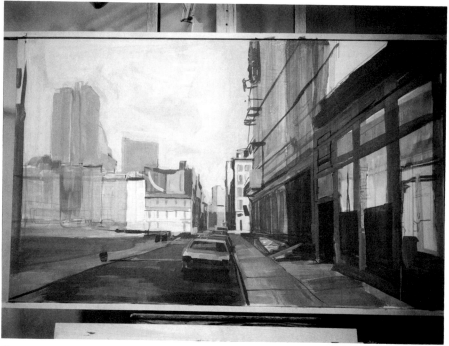

2

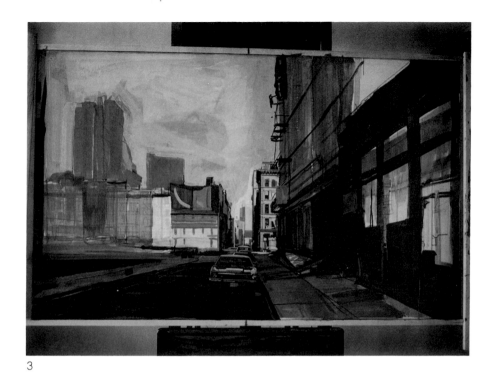

3

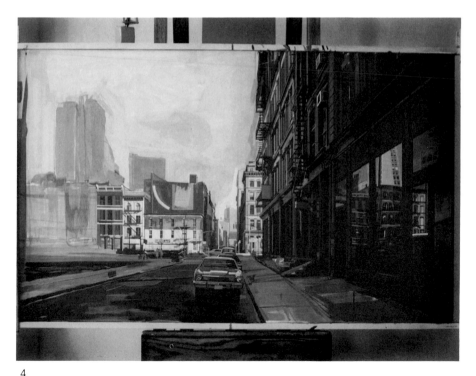

4

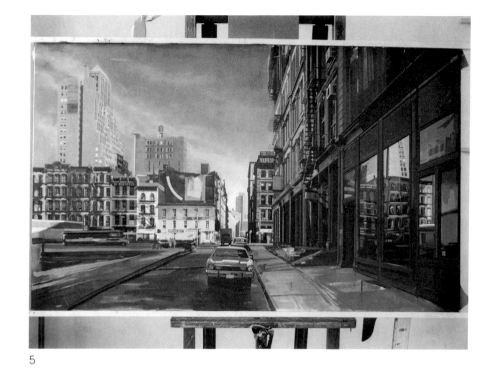

5

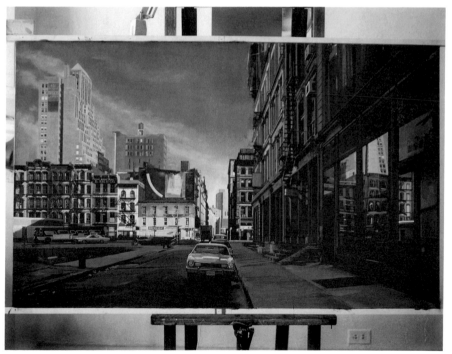

6

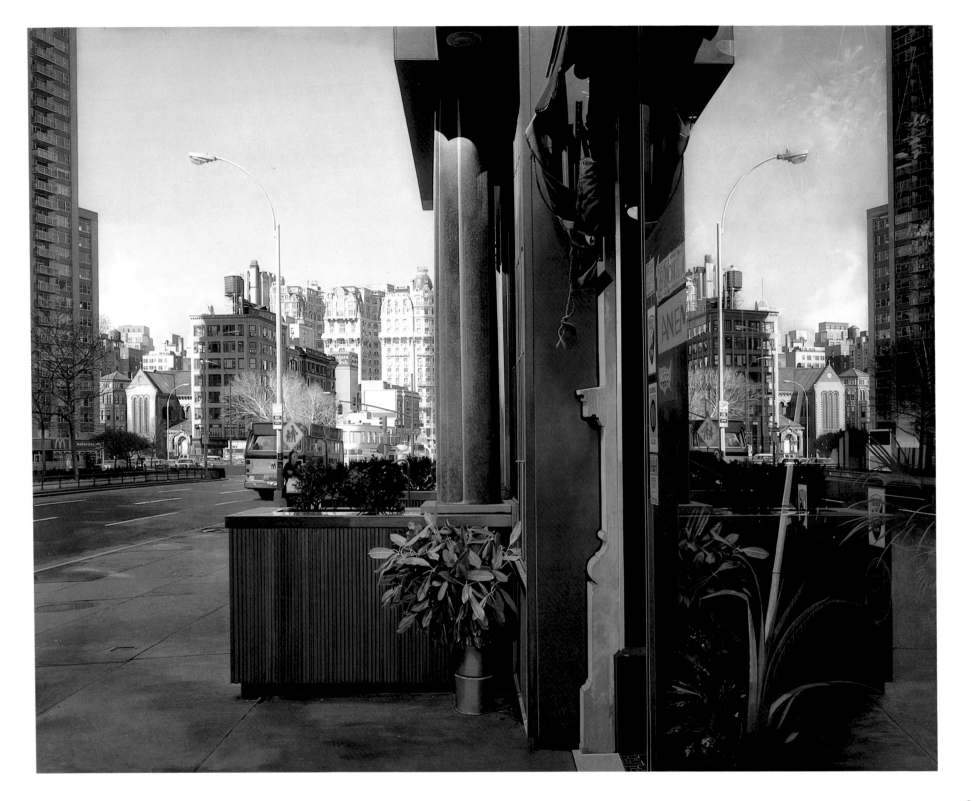

21 *Ansonia*, 1977

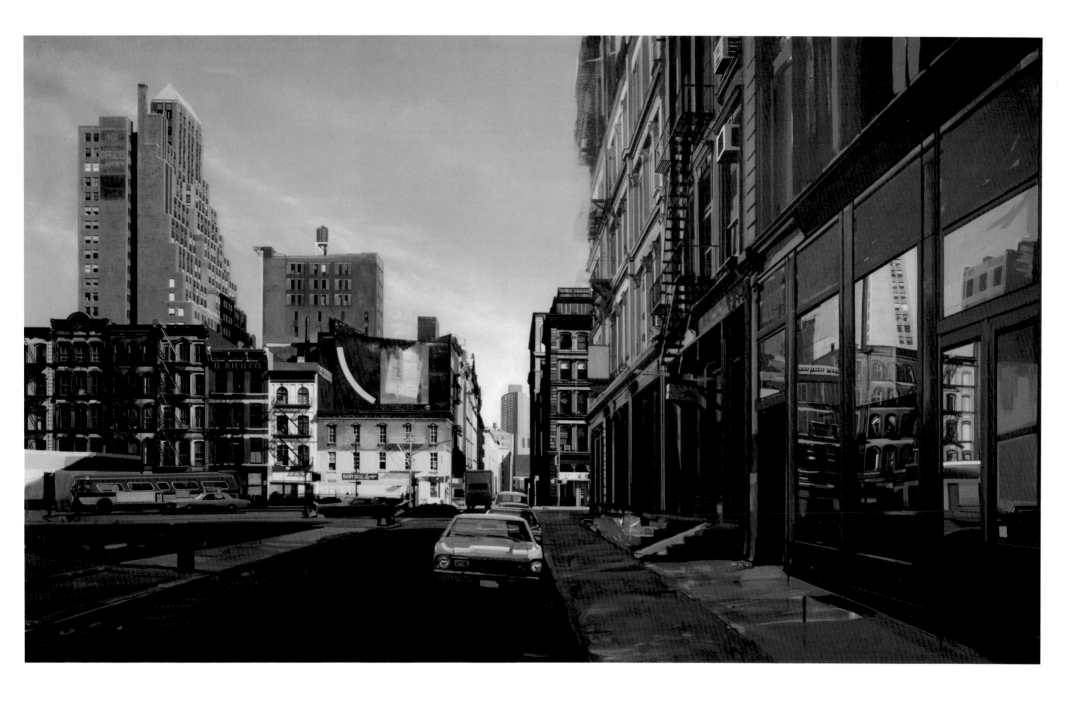

23 *Baby Doll Lounge* (work in progress), 1978

COLLECTIONS

Academy for Educational Development, New York
American Broadcasting Company, New York
Art Institute of Chicago
Mr. William Bernhard, New York
Mr. and Mrs. Leigh B. Block, Chicago
Mr. and Mrs. H. Christopher J. Brumder, New York
Centre National d'Art et de Culture Georges Pompidou, Paris
Mr. and Mrs. Malcolm Chace, Jr., Rhode Island
Dr. Jack Chachkes, New York
Des Moines Art Center, Iowa
Mr. and Mrs. Robert Feldman, New York
Mr. Graham Gund, Cambridge, Massachusetts
Senator and Mrs. John Heinz III, Pennsylvania
Hirshhorn Museum and Sculpture Garden, Smithsonian Institution, Washington, D.C.
Mr. Paul Hottlet, Antwerp
Ivest-Wellington Corporation, Boston
Sydney and Frances Lewis, Richmond, Virginia
Ludwig Collection, Aachen
Metropolitan Museum of Art, New York
Museum of Modern Art, New York
William Rockhill Nelson Gallery of Art—Atkins Museum of Fine Arts, Kansas City, Missouri
Mr. Donald Newhouse, New Jersey
Mr. Morton Neumann, Chicago
Neumann Family Collection, New York
Mr. and Mrs. Stephen D. Paine, Boston
H. H. Thyssen-Bornemisza Collection
Toledo Museum of Art, Toledo, Ohio
Mr. J. E. Treisman, California
Mr. Thomas Vail, Ohio
Whitney Museum of American Art, New York